Digital Filmmaking for Beginners

A Practical Guide to Video Production

Michael K. Hughes

New York Chicago San Francisco
Lisbon London Madrid Mexico City
Milan New Delhi San Juan
Seoul Singapore Sydney Toronto

The McGraw·Hill Companies

Cataloging-in-Publication Data is on file with the Library of Congress

Digital Filmmaking for Beginners: A Practical Guide to Video Production

2 3 4 5 6 7 8 9 0 QFR QFR 1 0 9 8 7 6 5 4 3

ISBN: 978-0-07-179136-6
MHID: 0-07-179136-1

Sponsoring Editor
Roger Stewart

Editorial Supervisor
Jody McKenzie

Project Editor
Howie Severson, Fortuitous
Publishing Services

Acquisitions Coordinator
Molly Wyand

Copy Editor
Lisa McCoy

Proofreader
Emilia Thiuri

Indexer
Karin Arrigoni

Production Supervisor
James Kussow

Composition
Cenveo Publisher Services

Illustration
Cenveo Publisher Services

Art Director, Cover
Jeff Weeks

Contents at a Glance

WITHDRAWN

About the Author

At the age of twelve **Michael Hughes**' father insisted that he should have a movie camera. That's when he began to fall in love with the moving picture art form. He followed his father into broadcasting, where he spent several years in television, working on both educational and broadcast programs. Michael eventually created a business that produces corporate videos for companies looking to augment their employee training or product promotional efforts. He also works on documentaries and "how to" videos for the consumer market.

Since about 1973 Michael has been teaching filmmaking and now video production at the British Columbia Institute of Technology, Vancouver Film School, and lately Langara College. His teaching career in film/video production now spans 32 years. As a result, it only makes sense now for him to release a textbook on everything included in his well-honed course, plus a whole lot more that he's learned along the way.

Contents

Preface

The purpose of this book is to give you the best possible type and amount of information to begin a career in producing high-quality video programs, to add to the knowledge you already have if you're currently in the business, and to encourage you to improve the videos you make—even if you are only making videos for yourself and your family. But, this is more than just a coffee table book that glosses over the information. This book is stuffed with information. There are a lot of text, pictures, and illustrations to absorb.

If you're serious about learning more about video production—from the ground up—this book is for you! I encourage you to give the book a thorough read, or, if you're experienced enough, look at the table of contents and pick the subjects you might like to know more about. Either way, you're bound to benefit from the information herein.

Enjoy the read!

Online Resources

More informative material is available to supplement what you'll read in this book. There are tutorial videos and extra articles, as well as course materials for film instructors. Check it out at www.mikesdvp.com.

Acknowledgements

Gotta thank my broadcaster father, Ken Hughes, who insisted I have a movie camera when I was about 12 years old, which he bought for me out of my allowance (thanks, Dad!). Really, this is where it all began for me.

My wife, Linda, and my daughter, Ashley, have been both patient and helpful in many ways they aren't even aware of…mostly to do with my sanity.

When it came time to have some proofreading and editing chores, I submitted unfinished copies to a few of my friends. One ex-student of mine who has become a very good friend, J.B. Krause, was invaluable in catching so many of the typos, spelling errors, structure, and design faults that plague even good authors. The professionals at McGraw-Hill Professional did a great job of correcting the rest.

Kerry Elfström has been the best associate and friend a self-employed filmmaker could ever have. Over the years, he has, through his instructional business, hired me to create many different types of video and audiovisual projects. Having to create a huge variety of weird and wonderful productions for Kerry has taught me how to think and work outside the box.

1

Film and Video: History and Technical Aspects

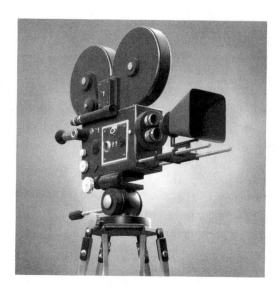

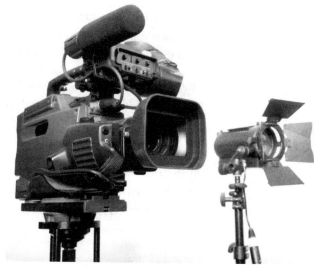

The technology behind modern video dates back to when film was the only viable method of capturing and presenting the moving image. Many people today refer to video as a film while, in fact, there is a vast difference between actual photographic motion picture film and the modern video. Suffice it to say that the older terminology has been adopted to suit our modern methods. But I believe it's important to know the actual differences between these two very different methods of presenting motion images.

Film vs. Video: The Differences

Video production technology is part of a history that harkens back to long before the introduction of full-color digital video with dazzling high-fidelity surround sound and spectacular visual effects. It goes back further than motion picture film, and even back further than photography itself. So, let me quickly bring you up to date.

The Birth of Photography

If we go back several hundred years, we could say that the art form has its roots in the live performances of puppet shows performed behind a backlit screen where stories were told in black-and-white shadow images to the audience viewing the front of the screen. This form of theater is still practiced in some countries, such as Indonesia, as a cultural art form and has been used for centuries to pass down religious teachings as well as for entertainment.

To liken these "shadow shows" to today's motion pictures may seem a bit of a stretch, but once you understand the basic theory behind motion pictures as they are projected on a theater screen, you will realize just how alike they really are.

Joseph Neipce (Figure 1-1) is credited with creating the first permanent photographic image in 1824. Neipce, a chemist and inventor, had been experimenting with silver as a light-sensitive compound for capturing an image, but turned eventually to bitumen for his early experiments.

In 1829 he partnered with Louis Daguerre (Figure 1-2) to develop improved photographic processes. When Neipce died in 1833, Daguerre continued to improve the process and eventually introduced the "daguerreotype," a photograph captured on a metal plate

FIGURE 1-1 Joseph Neipce

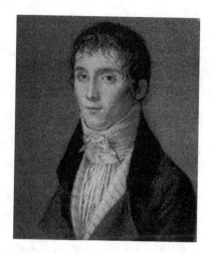

coated with a silver halide compound. Silver has been the main component of photographic chemistry ever since.

Photography flourished from this point, and many improvements were made over the next 175 years, including the introduction of paper prints from a plastic negative—and the inventive contrivance of motion picture technology.

FIGURE 1-2 Louis Daguerre

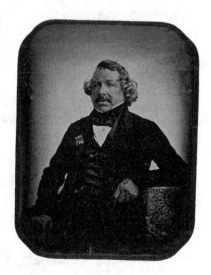

How Photography Works

Traditional photography, unlike digital photography, is a chemistry-based medium. Both Neipce and Daguerre realized the potential of silver as a light-sensitive element that could be used to re-create a live scene. By the time plastic negatives were invented, the process was refined to the point it is at today. Here is the recipe:

1. Take a very fine powder of silver salts and suspend it in gelatin to keep it from falling off the plastic base. This is called photographic emulsion.

2. Expose the emulsion to light, focused through a lens, reflecting from a subject (see Figure 1-3). The more light exposure there is, the more the silver salts react by tarnishing.

3. Then, in a darkened room, subject the negative to various chemical baths to wash away the silver emulsion that is unexposed (the dark parts of the scene

FIGURE 1-3 The more light, the more the silver salts react by tarnishing

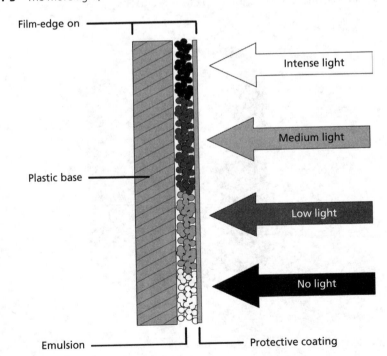

from which no light reflected into the lens). Don't forget to save the silver that disengages from the plastic. It is silver, after all, and is valuable.

4. Fix the remaining exposed silver permanently to the plastic base with another chemical bath.

5. Next, as we have only a negative image, shine a light through this plastic negative, through a focusing lens, and onto a piece of light-sensitive paper or another piece of plastic film coated with silver salts emulsion. Where there is a dense buildup of emulsion (the dark or opaque part), the light will not be able to pass through. Where the plastic is void of silver (the clear part), the light can shine through to expose the paper or film. When chemically processed, this "print" will be a positive representation of your scene.

While still images are usually printed on paper, some are printed onto new film to create a positive image in the form of a slide.

Motion pictures are printed to a new strip of emulsion-treated, celluloid plastic film. This film is perceived as a long strip of celluloid with many small images on it—each image slightly advanced in motion from the one preceding it. And indeed it is, in its finished form. But, the raw, unexposed film is really just a long strip of plastic with a silver emulsion applied (see Figure 1-4), just like the film for still pictures but much longer.

When the film is pulled through the camera by virtue of the sprocket holes on the edges, it stops for a fraction of a second so that the camera's shutter can quickly open and then close while the film is being held still to record one frame (picture) on the film. Then the film advances to the next frame and stops again so the process can repeat. This is called the intermittent action of the camera, and is why the frames are all so precisely placed and the images are not blurred by the motion of the film.

Now, imagine you are in a theater. The lights go down, the curtains open, and the film begins rolling through the projector. The same intermittent action allows the shutter to open and project a still image through a focusing lens and onto the screen. Then the shutter closes, plunging the theater into darkness, and the film is pulled down one frame, held perfectly still, and the shutter opens again to project the next frame.

FIGURE 1-4 The three main components of black and white film

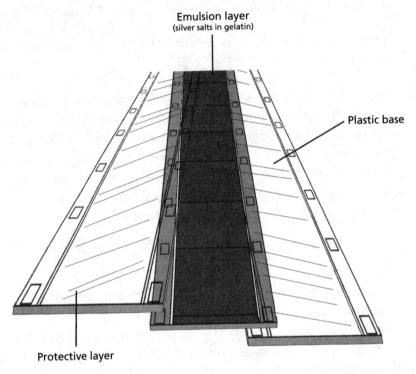

Emulsion layer
(silver salts in gelatin)

Plastic base

Protective layer

Because this happens 24 times each second and the shutter is closed for only a fraction of a second each time, you aren't aware of the dark between the frames. The light is what activates your vision, and each frame or picture stays on your retina while the theater is in darkness. This human phenomenon is known as persistence of vision, or image retention. You are not able to "see the dark parts" between projected frames. The brain seamlessly transitions from one frame to the next to give you the perception of motion on the screen. Pretty neat, eh?

Now, if you stop to think about it, how different is that from the shadow shows mentioned earlier in this chapter? The light is shining through the clear areas of the film and is blocked by those parts that are dense with emulsion particles. The density of the emulsion determines the darkness of the image. An old black-and-white Humphrey Bogart film would show a close-up of Bogey as a shadow. Not a silhouette, but as a detailed shadow in shades of grey.

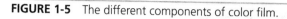

FIGURE 1-5 The different components of color film.

Protective layer —————

————— Plastic base

Red layer Green layer Blue layer

That's all very well for black-and-white movies, but what about color film?

Color film works exactly the same way as black and white, except that color film has three layers of emulsion (see Figure 1-5). One is chemically screened to record only light of the red frequencies, one for blue, and one for green. These are the three primary colors of light—red, blue, and green (RGB). When these colors are mixed together in their varying shades and hues, they can create any color in the visible spectrum. It's the same as three-color printing, where the paper is passed through the printer three times, once for each primary color (although the primary colors for inks, dyes, and paints are red, blue, and yellow instead of red, blue, and green…go figure!).

Now we have a shadow show in full color! Things have come a long way.

On to Video

Like most technologies, modern video systems did not just spring into existence fully formed. However, it has enjoyed very rapid development.

The History

Television technology was slowly developed by many people in many countries, but the first truly electronic television system (both the camera and the television receiver)

FIGURE 1-6 Philo Farnsworth

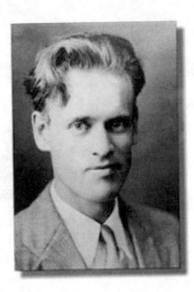

is credited to American inventor Philo Farnsworth (Figure 1-6), who developed the system between 1926 and 1939 when he sold the rights to RCA Victor.

Television's public debut was the broadcast of several events at the 1939 World's Fair in New York. Later, Mr. Farnsworth was quoted as saying, "There's nothing on it [television] worthwhile, and we're not going to watch it in this household, and I don't want it in your intellectual diet." True story!

Oh well, we watch it anyway (sorry, Philo). And because we watch so much and demand the ability to see programs again and again at different times, the television industry needed a device capable of recording and playing back programs (and, of course, commercials).

Enter the Videotape Recorder

The earliest experiments to produce a viable videotape recorder/player utilized modified audiotape recorders that ran quarter-inch tape at speeds up to 360 inches per second to create a linear video track. The pictures were of a very poor quality, and the fast running speed meant that they could only record a few minutes of programing.

Charles P. Ginsburg was the leader of the research team at the Ampex Corporation that invented the first practical videotape recorder (VTR) in 1951. That first machine sold for $50,000 in 1956.

While there were still signal quality and program length considerations, further advancements in technologies, such as quad recording (recording by scanning the tape across its width) and finally helical scanning (recording in diagonal stripes), which is in use today and discussed below, finally made VTRs a staple for every broadcast and video production company.

The Technical Bit

The way in which the picture information is striped onto the tape in long, diagonal scans is an efficient way of maximizing the amount of video information that can be recorded on a given length of tape. This is called a Helical scan. In Figure 1-7, notice the two linear audio tracks at the top of the tape and the control track on the bottom. The control track is a timing track that ensures that the playback heads synchronize with the video stripes that were laid down during recording.

The video record/playback heads and the erase heads are rapidly spinning within a gap in the head drum assembly. In the figure, the gap is not shown so that it won't be confused with the indication of the recorded track. As you can see, the head drum is tilted to create the diagonal signals to be recorded onto the magnetic oxide of the recording tape.

In Figure 1-8, you can see the U-Matic threading pattern, which allows a maximum amount of tape to be recorded at once (longer diagonal stripes than would be possible with a "flat" pass across the heads).

FIGURE 1-7 Magnetic recording and the Helical scan

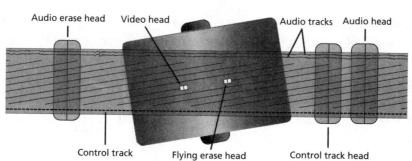

FIGURE 1-8 Videotape threading path

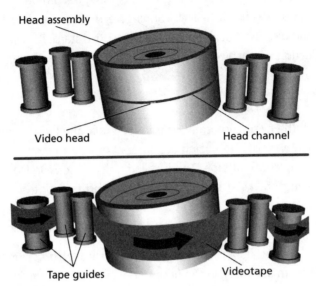

While there are static record/playback and erase heads for the linear sound tracks, we've left them off this diagram to demonstrate the rollers that guide the threading path. There are usually two heads in a stack that create and play back the channel 1 and channel 2 linear sound tracks. There will also be a general erase head that can erase all information on the tape prior to being rerecorded on so that there is no chance of technical difficulties resulting from old information conflicting with new information as it is recorded. There is also a static head, which will record and play back the control track that synchronizes the video playback heads with the diagonal video stripes.

Within the head drum assembly resides either two or four record/playback heads for picture (depending on format and recorder size), one flying erase head to ensure stable edits of the picture track when new picture material is inserted on an editing recorder (or when the recorder within a camera system stops and starts to make multiple shots), and perhaps an audio head to record high-fidelity audio, which is recorded on the same part of the tape as the picture tracks, but embedded deeper in the oxide.

This is the way video cassettes have worked since analog times. Even digital recording uses this same method for recording data. The main difference between analog and

digital recordings is that because digital uses the same technology that allows computer hard drives to store information, there is more redundancy in the signal, which ensures a clearer, more artifact-free image that can be manipulated in the digital realm.

A Word about Analog vs. Digital Video

Okay, this is a tough one. The intention of this book is to help you understand and practice the "hands-on" of producing videos. It is *not* a reference book for electronics technicians. As such, this section on what is analog and what is digital will be brief on the technical information and will focus on how the new digital technology helps the producer to make videos. Aren't you glad?

I have read definitions of analog and digital signals in manuals and reference books written by the technical geniuses who design video production and post-production gear, and I don't think that even they understand what they've written sometimes.

Suffice it to say analog systems are the old, original way of doing things electronically. In analog, video signals are laid down by recording modulating pulses (see Figure 1-9). How yucky is that?

Digital is the new and (for the most part) better way. Digital signals are made up of signals that are analogous to the ones and zeros used in the binary language of computers (see Figure 1-10).

In the early days of video, everything was analog. As we progressed into the digital age, brought on by the need for smaller, faster computers, it became obvious that the lower-quality picture and sound transmitted by an analog signal was just not going to cut the mustard in the new digital age.

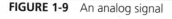

FIGURE 1-9 An analog signal

FIGURE 1-10 A digital signal

1001010111010000111001010110100001101011

One disadvantage of analog becomes apparent when compositing a multiimage picture. An example might be a background image with a live action, picture-in-picture box in one corner, a graphic logo in another corner, and a text graphic overlay in the center of the frame—all originally separate images. This might have taken four passes of the background image, three passes of the logo image, two passes of the picture-in-picture image, and a final pass to complete the full image with the text overlay. Depending on the quality of each original image and the format you might be working in (two-inch videotape at a high-end production studio versus half-inch video in a home editing suite), your background images might begin to look "noisy" or "grainy" after a few passes.

Another example of the horrors of analog can be seen if you duplicate videotape A onto videotape B and then use videotape B to copy onto videotape C and then use videotape C to copy… you get the idea. In the analog days, your picture and sound would suffer noticeably after the second duplication, and be trash by the fourth (see Figure 1-11).

Enter Digital Video

With digital, you can layer virtually as many images as you like with no noticeable degradation of quality. Cool! Now we can do all of those fancy, juicy special effects and graphics builds formerly only afforded by Hollywood production companies and big television networks. We can also make duplications from duplications from duplications as long as we like. Well, not really. There is a point at which even a digital signal will become corrupted and lose quality, or begin to "pixilate," but that's so far down the duplicating line that most of us will never be bothered with it.

FIGURE 1-11 As analog video is copied over and over, picture and sound degradation is readily apparent.

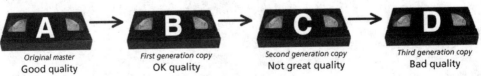

| Original master | First generation copy | Second generation copy | Third generation copy |
| Good quality | OK quality | Not great quality | Bad quality |

Old VHS videotapes would eventually fall prey to "dropouts." This is where the metallic oxide particles that are bound to the plastic surface of the tape and hold the magnetic information would fall off in small chunks. The symptom of this is quick flashes or streaks in the picture. Digital videotapes don't fall victim to this problem because of the amount of redundant signal backup that can be fit onto the tape. If the zeros and ones become corrupted on one microscopic part of the tape, they will likely be readable from another area on the tape nearby. Of course, too much damage to the tape will eventually cause digital breakup of the picture and sound. Nothing's perfect (yet).

As the next chapter explains, we will eventually be recording all data on static memory cards. For video, this is already beginning and when it permeates, the whole production industry—from camera recording to post-production and archiving—will have achieved a technological nirvana at an affordable price that will cause many video producers to quote that famous old saying, "I musta done died and gone to heaven!"

Digital technology isn't perfect, but it's pretty darn close!

DVDs

So far we've been talking about formats for capturing video with a camera as well as playing it back for the audience. It seems reasonable at this point to mention DVDs because they are a popular method for playing back prerecorded material. I would like to make it clear, though, that DVDs are not great as an original camera-capture format, as the images are at once compressed to mpeg-2 (see the compression formats near the end of this chapter). While this is okay for consumer cameras, as long as the user is not considering complex editing of their footage, it is not of a quality that professionals require to capture the best possible original footage. As a method of playing back a finished program, however, DVDs and Blu-ray rock!

Plugs and Connectors

In Figures 1-12 through 1-25, I've depicted some of the common connectors, both analog and digital, that you'll encounter in video work. These connectors include the following:

- **Phono plugs (male)** These are used for patching audio and analog video signals. The yellow one is always video, and the other two are left and right audio (see Figure 1-12).

FIGURE 1-12 Phono plugs (male)

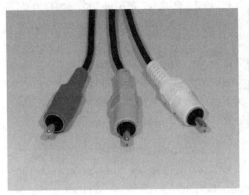

FIGURE 1-13 AV cord (male)

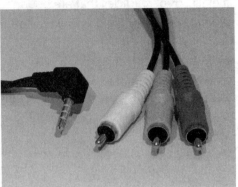

FIGURE 1-14 Stereo headphone jack (male)

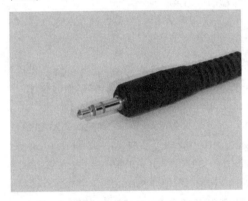

FIGURE 1-15 1/4" phone plug and XLR plug (male)

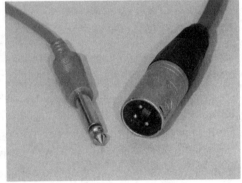

- **AV cord (male)** This is used for patching audio and analog video signals. The camera end is a multiconnection, 1/8" phone plug (see Figure 1-13).

- **Stereo headphone jack (male)** You'll find either a 1/8" or a 1/4" plug on the cord from your headphones (see Figure 1-14).

- **1/4" phone plug and XLR plug (male)** These are microphone plugs. A high-impedance mic will have a phone plug, and a low-impedance mic (or mic cable) will sport the XLR (see Figure 1-15).

- **FireWire connector, large and small (male)** These are used mainly for connecting your camera to your computer to capture your footage onto your computer's hard drive (see Figure 1-16).

FIGURE 1-16 FireWire connector, large and small (male)

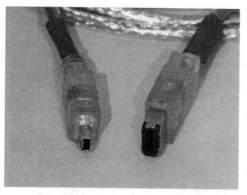

FIGURE 1-17 FireWire 800 and 400 connectors (male)

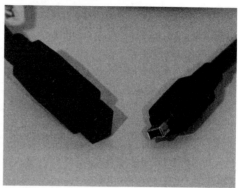

FIGURE 1-18 USB connectors (male)

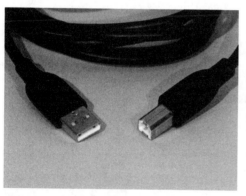

FIGURE 1-19 BNC connector (male)

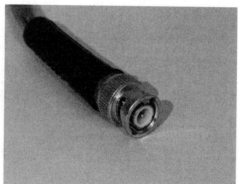

- **FireWire 800 and 400 connectors (male)** The 800 provides faster transfer speeds (see Figure 1-17).

- **USB connectors (male)** There are two sizes of USB connectors. This cord has both. As with FireWire, the small one accommodates the camera (see Figure 1-18).

- **BNC connector (male)** This carries an analog video signal (no audio) and is found on professional cameras (see Figure 1-19).

- **S-video plug (male)** This separates chrominance from luminance in an analog video signal for better picture quality (see Figure 1-20).

FIGURE 1-20 S-video plug (male)

FIGURE 1-21 RCA and S-video plugs (female)

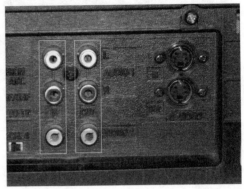

FIGURE 1-22 HDV FireWire and RCA phono (female)

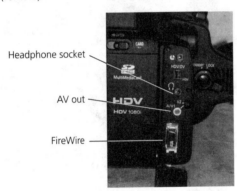

Headphone socket

AV out

FireWire

FIGURE 1-23 USB and FireWire inputs (female).

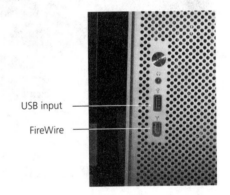

USB input

FireWire

- **RCA and S-video plugs (female)** On the left are the RCA phono ins and outs for a stereo VCR, and on the right are the S-video sockets (see Figure 1-21).

- **HDV FireWire and RCA phono (female)** The back of my camera shows the AV (analog) video/audio output, headphone socket, and FireWire in (see Figure 1-22).

- **USB and FireWire inputs (female)** On the computer are the receptacles for the USB and FireWire inputs (see Figure 1-23).

- **BNC connector (female)** Analog video (only) output on many professional cameras (see Figure 1-24).

- **XLR microphone inputs (female)** For professional, low-impedance microphones (see Figure 1-25).

FIGURE 1-24 BNC connector (female)

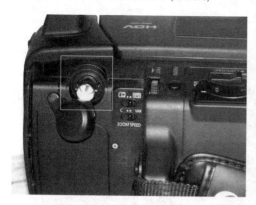

FIGURE 1-25 XLR microphone inputs (female)

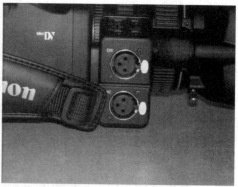

High-Definition and Aspect Ratios

While digital video has given us much better quality and more capabilities in special effects, it has also brought along a number of issues that need to be understood because some of them are potentially confusing. First, let's look at aspect ratios. The aspect ratio of a picture is its measurement ratio of width to height. Old-style TV screens (from the 1940s on up to about the early 2000s) had an aspect ratio of 4:3 (actually, 1.33:1, which is usually just called a 4 to 3 ratio) (see Figure 1-26). No matter the size of the screen, the ratio between width and height was always 4:3. Today, when you buy a new TV you will likely purchase a 16:9 screen (1.78:1, usually referred to as a 16 to 9 ratio) (see Figure 1-27).

FIGURE 1-26 Old-style 4:3 TV. Notice the sides are cropped.

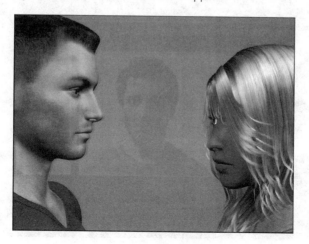

FIGURE 1-27 Newer-style 16:9 TV with the full image shown

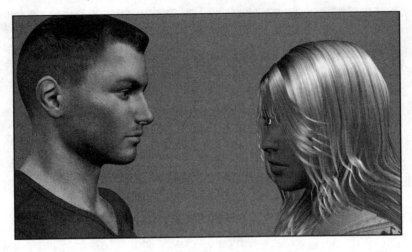

On a movie theater screen, you will usually see a movie in 1.85:1, or perhaps 2.39:1. This can explain why you often see movies on your high-definition television that have black bars at the top and bottom of the picture. The movie format being shown is a widescreen theatrical release print and must be "letter boxed" to fit the whole image on the screen at once (see Figure 1-28).

FIGURE 1-28 The "letter box" format displays the movie as it appeared on the movie theater screen.

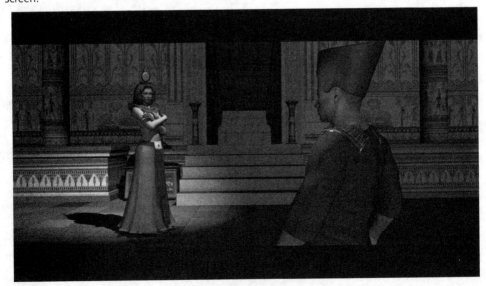

FIGURE 1-29 This movie has been recropped for television.

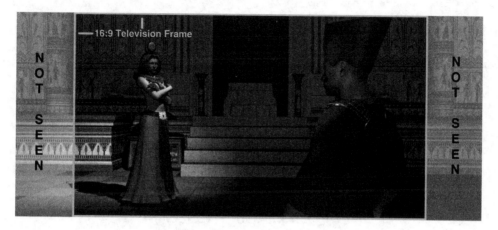

If the movie has been recropped for television, it will fill your TV screen, but the left and right sides will be somewhat cropped. This television version of the movie will use electronic panning or will simply cut to a composition that allows the right or left side to be seen when appropriate (see Figure 1-29).

Most people don't mind the letter box option so they can see the movie as it was meant to be seen.

Standards for still photography, which may affect your video compositions when you are showing photographic stills in your program, include 4:3, 3:2, 16:9, 5:4, 6:7, and 1:1 (square). The 4:3 standard definition, 16:9 standard definition, and 16:9 high definition formats require you to set up all of the parameters in both your camera and your editing software very carefully.

Television Standards Around the World

Ever since television has existed there have been differences in how it works in various countries. Older style television sets that employ a cathode-ray tube (CRT) work by scanning the television image onto the back of a phosphorous-active screen a line at a time. Standard analog TV in North America is interlaced TV and it works by having a CRT scan lines 1, 3, 5, 7, 9, etc. (all the odd lines) first from top to bottom in 1/60th of a second. Then the gun draws out lines 2, 4, 6, 8, 10, etc. (the even lines), again in 1/60th of a second. This completes one full frame of the moving image in 1/30th of

FIGURE 1-30 The television standards used in various parts of the world. (This picture is licensed under Creative Commons Attribution ShareAlike 2.0 License.)

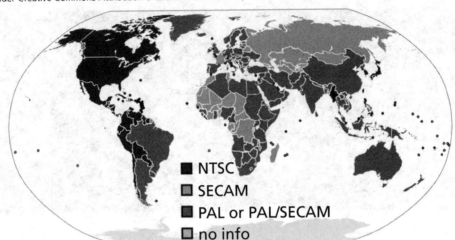

- NTSC
- SECAM
- PAL or PAL/SECAM
- no info

a second (1/60th plus 1/60th). In the North American Standard, 525 lines are drawn in this way for each frame. This is called NTSC, which stands for National Television System Committee. As seen in Figure 1-30, this standard is used in North America, some parts of South America, a small part of Africa, and some Asian countries.

Secam (Séquentiel Couleur À Mémoire) is used in France (where it was first created), Russia, Asia, and several countries in Africa. It utilizes 625 lines at a frame rate of 25 frames per second (fps). PAL (Phase Alternation by Line), developed in Germany, is used in that country, as well as in the rest of the other countries in the world. It also uses the 625 line, 25 fps system.

Because of these differences in analog television signals, importing foreign television programs and videos required standards conversions that were often expensive and degrading to the signals. Hopefully, the new age of digital video will solve this problem. Discussions among governing bodies from all countries are still trying to iron out the technical specifications for a universal standard.

Video Formats

Finally, in this chapter I want to introduce you to several of the many video formats in which you can output your final program after the post-production process. I'm going to try to stay away from influencing you to embrace any particular format as a favorite, as you will likely find uses for many of them. Many formats have very specific uses.

Table 1-1 lists in alphabetical order each format's uses and strengths. Whew! There are dozens and dozens more formats, but these are the most common.

TABLE 1-1 Common Video Formats

FORMAT	TYPE	POPULARITY	USES AND STRENGTHS
.avi	Audio Video Interleave	Very common	Typically uses less compression than other formats.
.dat	VCD Video	Average	Used to make video CDs.
.avi	Audio Video Interleave	Very common	Typically uses less compression than other formats.
.dat	VCD Video	Average	Used to make video CDs.
.dvx	Div X Video	Average	High-quality video compression. Needs plug-in or Div X player.
.fcp	Final Cut Project	Average	
.flv	Flash Movie File	Very common	
.m2t	High Definition DVD	Average	HDV compression scheme for camcorders. Uses MPEG-2 compression.
.m2ts	Blu-ray High Def. DVD	Average	BDAV format for Blu-ray disks. High def. based on MPEG-2.
.m2v	MPEG-2 Video	Average	MPEG-2 with video only. No audio. Used for making DVDs.
.m4v	iTunes Video	Common	
.mov	Apple QuickTime	Very common	
.mp4	MPEG-4 Video	Very common	
.mpeg	MPEG Movie	Common	
.mpg	MPEG Video File	Very common	
.mts	AVCHD Video	Common	Used by Sony, Panasonic, and other HD camcorders.
.qt	Apple QuickTime	Common	Cross-platform format for Mac or PC. Good player control capability.
.rm	Real Media	Common	
.swf	Flash Movie	Very common	Used for web movies and animations (can contain vector or raster graphics and text). Best compression for web streaming. Good quality, but small file size.
.vob	DVD Video Recording	Very common	
.wm	Windows Media	Average	Same as Windows Media Video, but simpler. Can contain video and audio.
.wmv	Windows Media Video	Very Common	An .asf file that is encoded using the Windows Media Video codec. Player capability is often restricted.

2

The Camera

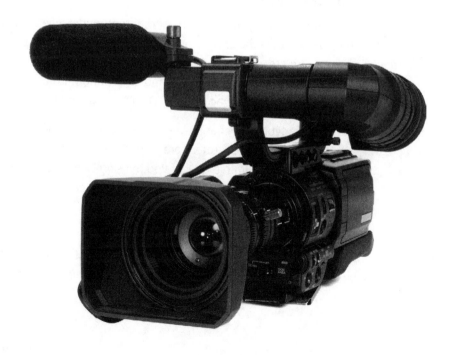

Video cameras come in all shapes, sizes, and prices. It can be a bit of a challenge to choose the right camera for what you want to do.

Camera Types, Functions, and Accessories

We all know what a camera is for, but there are many functions and features that professional filmmakers need to be aware of.

Pricing

For many people just starting out, price is a definite factor in their buying decision. Figure 2-1 and 2-2 show two cameras you could choose from, but one is ten times the cost of the other. If you can afford it, you'd be advised to get the more professional camera. After all, I assume that by reading this book you're more interested in shooting something that looks professional than just capturing the family holiday at Disneyland.

Both of these cameras are made by highly respected and innovative companies, and both companies have a range of camera styles and costs to choose from.

Media Types

There are a plethora (that's a lot!) of different media types. "Media types" refers to the type of media the camera uses to store the images and sounds. A few of the choices here are videotape, Mini DVD (not to be confused with Mini DV, which is a videotape format), memory sticks and cards, and hard drives. In the tape category, the main choices are Betacam, Mini DV, DV-Cam, and DVC-Pro.

Other media types are (thankfully) obsolete and no longer supported in newly manufactured cameras. I refer here to VHS, Super-VHS, 8mm, and Hi-8mm analog systems, as well as 8mm digital. If you're using Mini DVD, memory sticks/cards, or hard drives, you can forget the information on tape scanning modes and U-Matic threading covered in the previous chapter.

Capture Formats

"Capture formats" refers to the electronic signal laid down on the media. Table 2-1 lists some common ones.

FIGURE 2-1 This Handycam is great for family videos. It costs a couple of hundred dollars.

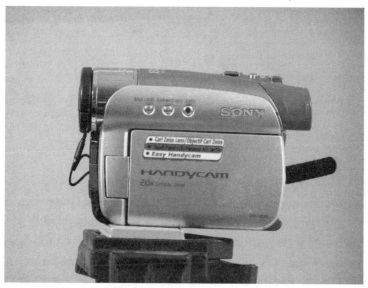

FIGURE 2-2 This more professional camera captures better pictures, has better sound, and has many high-end features and functions. It costs several thousand dollars.

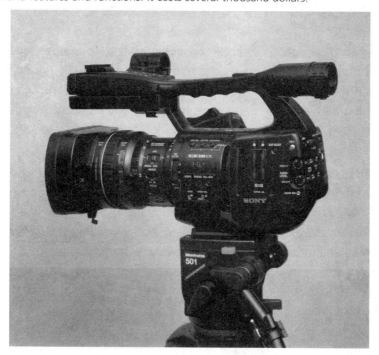

TABLE 2-1 Most Prevalent Current Tape Capture Formats

Digital Betacam	High-end television broadcast format with the best image and sound, but expensive to produce and post in.
DV Cam	Excellent quality. Best format for corporate videos, festival films, and documentaries. The quality is good enough for television, but not as good as Betacam.
DVC-Pro	Same as DVC-Pro.
Mini DV	In lesser expensive cameras, this format is strictly a consumer format. In more expensive cameras, it is used for corporate videos, documentaries, etc., and is good enough for some broadcast programs.

The first two formats were invented by the Sony Corporation; the next two represent Panasonic's entry into the market. The Mini DV tape format is utilized in camera systems available from several manufacturers. Since the Mini DV tape type is used in Sony's DV Cam, the cameras are usually able to record in either DV Cam or standard Mini DV format. Mini DV tape can also be used to capture high-definition video. Other formats include systems that record directly to Mini DVD discs, hard drives, and static memory sticks and cards.

If you are considering one of these formats you must be aware of several limiting factors:

- Mini DVD camcorders compress the video in MPEG-2 codec directly to the disc. This makes editing the video difficult, first because the sound track and the video are "muxed," or mixed together on the same track, and many editing software packages will not be able to locate or play back the audio. Second, the quality of original camera footage compressed to a DVD format is not as good as a raw video signal.

- Hard drive cameras work fine, but they don't help when the drive fills up and you want to archive your unedited footage for future use. The manufacturers of these cameras usually suggest that you transfer the footage to your computer's hard drive to do your editing, but say nothing about clearing your computer drive and being able to archive your footage. Endlessly buying hard drives is too expensive to consider, so the best answer is to have a tape recorder to transfer footage to for archiving. Might as well shoot on tape in the first place!

- Static memory devices (sticks and cards) are the most popular format today. First, they are simply memory chips—no moving parts to break down. Second, their transfer rate for the video and audio information is fast. When one fills up, you can quickly and easily swap in a new one. And last, they take up very little shelf space when used as a device to archive your footage. In their current format, the amount of raw video that even the largest-capacity versions can hold is low and the price is still somewhat high. When we can buy 60 minutes capacity (or more) of a static memory device for our camera for less than $8.00 each (as you can now buy Mini DV tape), they will be the *only* way to go.

By the time you read this book, much of what has been written in the last few pages may be outdated and there may be other formats, compression schemes, and storage devices on the market. Most cameras sold today utilize static memory (mostly SD cards) to store captured shots, sound, and still pictures, although some of the other formats are still being sold, even tape. Camera technology tends to change much faster than an author's ability to keep a book updated. I suggest you keep up by reading current video magazines and books, visiting major manufacturer's websites to peruse the latest equipment and spec sheets, and talk to knowledgeable salespeople where professional camera gear is sold.

Common Camera Functions

While any camera you are looking to potentially purchase may come with a multitude of fancy features, some features are common to all video cameras, such as color balance, auto focusing, motorized (servo) zoom, an on-board camera microphone, etc. Standard definition versus high definition is becoming a nonissue now that high definition is taking the lead in sales. When considering a camera for purchase, take these factors into account.

Do These Standard Features Have Both Automatic And Manual Settings?

I may be getting lazy in my old age, but I really appreciate the automatic features built in to most cameras…but, the more features that can also be controlled manually when necessary, the better!

How Good Is The Lens?

Is it a dime-sized plastic lens or a real glass lens? Are there manual focus, zoom, and perhaps aperture control on the lens itself? This last consideration is usually found only on the more expensive cameras, but often, a less expensive camera will include at least manual mechanical focusing from the lens. "Manual" focusing from a rotating dial on the camera body is usually an electronic function, and it is often difficult to make precise adjustments.

Is There a Good Electronic Viewfinder?

We'll get to the little swing-out liquid crystal display (LCD) screen in a minute. Right now, we're talking about the diopter viewfinder that you put up to your eye to make critical focusing adjustments. The LCD screen is not the best instrument for making these adjustments, so a good, easily viewed electronic viewfinder is important. Unfortunately many of today's less expensive cameras do not have an electronic viewfinder.

What About That LCD Screen?

When I was just a beginner...never mind, I can't remember that far back. But I do recall that camera operators almost always used the trusty diopter viewfinder for framing and focusing. Nowadays most "newbies" use the LCD screen exclusively. I gotta admit that even I have fallen victim to the allure of a good LCD screen for viewing many types of shots. When the light you're working under allows for a good view of that little screen, it does let you occasionally avert your eyes to watch for things you're likely to trip over or bump into as you move around with the camera.

Things to consider when looking at cameras include making sure that the LCD is large enough and clear enough—even under bright light—to see properly, can be rotated around 180 degrees (and have the picture flip over so it's right side up when viewed from the actor's point of view), and can be folded against the camera so it can be used as a director's monitor while the camera operator uses the diopter. It's a benefit if they can both be used at the same time.

Another thing to be aware of is whether the playback controls are in the form of a touch screen. Personally, being an adult, non-elf-sized person, my fingers are much too large to easily use those controls on that tiny little LCD panel. I prefer actual, physical buttons. Suit yourself on that feature.

Is There a Microphone Input?

Most inexpensive consumer camcorders do not include a microphone input. This feature is mandatory if you are going to produce professional-looking and professional-sounding

videos. A more costly consumer camcorder might come with a mini-phone jack for microphone input. On this camera you can plug in a high-impedance microphone.

On a professional camera ($2,000 and up) you will likely have two XLR plugs to accommodate professional, low-impedance microphones. Not only do the microphones have better sound quality, but the low-impedance types allow for longer cable runs without sound drop-off.

Is The Camera Comfortable to Use?

I find it very difficult to use most modern consumer camcorders because they are too small for me to comfortably handle and the viewfinders are too tiny to see through properly (it's like trying to peer through a pinhole), but you might be okay with them. This can often be the deciding factor that pushes you over the edge to mortgage the family farm and buy a more expensive, professional camera.

Modern consumer camcorders can allow you to produce pretty good-looking images under optimal conditions, but for a full range of controls over many different picture and sound situations, you really need to save up your shekels and spring for the best you can afford.

Camera Mounts

A stable, static camera will always be the basic standard for professional-looking shots.

Tripods

While there is a lot of handheld camera work out there today, traditionalists, perfectionists, and professionals who really care about the look of their programs will mostly use a good camera mount for the majority of their shots, unless they are documentary filmmakers who have to shoot on the fly or are instructed by their director to give most shots a rough, point-of-view look.

The basic standard camera mount is the tripod (see Figure 2-3). These units come in all sorts of sizes and prices. Once again, the more you can afford to pay, the better the shots you can make with this tool.

While it's easy to think that a tripod's main function is to hold the camera steady, this is still-photography thinking. A still photographer's only concern with the way the

FIGURE 2-3 A tripod is essential to good filmmaking.

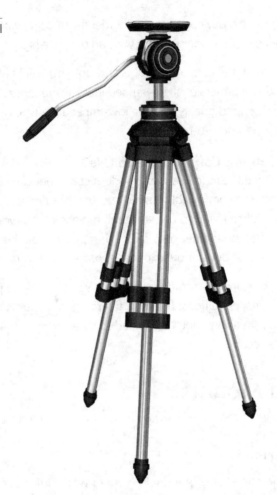

tripod is used is to be sure the camera is being held completely still, that it's not prone to unwanted movement, and that it's level. For this, all you need is a tripod with enough weight to easily support the size and weight of your camera and a level indicator on the tripod head.

The film or video operator must also be aware of how smoothly he or she can pan the camera back and forth and tilt the camera up and down. These are important considerations for the "moving picture" camera. It must move on these two axes smoothly! For this to be so, you should invest in a tripod that has a good, smoothly moving head.

The best option is a fluid head tripod, which uses silicon fluid sealed within the moving parts of the mounting head to smooth out the pan and tilt motions. It also will usually have adjustments to the amount of friction applied to the pan and tilt actions to counteract any shakiness in the operator's application of pressure during the move.

The next best (and less expensive) option is a tripod with "fluid effect." These tripod heads use Teflon pads that rub against each other to smooth the action. They aren't quite as smooth as a true fluid head, and the Teflon pads will wear out after a few years, but they will often work fine until you've hit the big leagues and can afford a better tripod.

Dollies

A camera dolly is really any wheeled vehicle that can move the camera forward and back (dollying) or from side to side (trucking) (see Figure 2-4). Most camera dollies are not motorized. They are operated by a person known as the dolly grip, who pushes, pulls, and steers the dolly by hand. This is so there are no motor sounds to disturb the sound track. If the camera is mounted on a car, truck, golf cart, etc., it is known as a camera car and is not really considered a dolly.

There are many types of dollies. A pneumatic crab dolly has a pneumatic camera mount on the wheeled platform that allows the camera to be raised or lowered a few feet using air pressure. Again, the dolly is manually operated, but there is a small motor that is only run between shots to charge the air tank that runs the pneumatic lift. When the lift is used during a shot, it is extremely quiet in its operation. There are often one or two seats on this dolly for the camera operator and, perhaps, the director, while the poor dolly grip struggles to push that much extra weight.

A dolly that is less expensive to rent or purchase is called a doorway dolly—so named because it is built to fit easily though a standard door opening. It has no pneumatic arm and may not have two seats, but it is easier to maneuver in tight situations.

Then there are track dollies. The pneumatic dolly mentioned earlier can be run either on rubber wheels that work well on a flat floor or, when the wheels are replaced with track wheels, on both straight and curved tracks. This makes operation smooth even on irregular or bumpy surfaces. Some track dollies are nothing more than flat boards with four pairs of skateboard wheels that you place your tripod on. Each skateboard

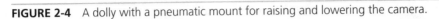

FIGURE 2-4 A dolly with a pneumatic mount for raising and lowering the camera.

wheel pair is mounted at 45 degrees to each other, and this will run smoothly on a standard plastic PVC plumbing pipe. This dolly is quite inexpensive to build.

While wheeled office chairs and AV carts have been used as dollies, the small wheels make smooth rolling next to impossible. A good alternative is a wheelchair. The large, rubber bicycle wheel makes for a smooth ride. While you will likely have to hold the camera, it is not bad if you prop your arm on the wheelchair arm rest. This should bring the camera viewfinder up to face level.

Jibs

Another type of camera mount that can be rented easily is called the jib (see Figure 2-5). It is meant for high-angle shots and those shots that are often called crane shots, where the camera moves dramatically from very low to very high or vice versa.

Unlike the very heavy, mechanically complicated, and expensive camera crane, which we won't cover here because we've all seen them in documentaries about the making of movies (you know…the monster that holds a Panavision camera, the camera operator, the director, his wife, and his entourage), the jib is smaller, lighter, less expensive, and can be operated by the camera operator from the ground.

FIGURE 2-5 A jib is useful for high-angle and crane-type shots.

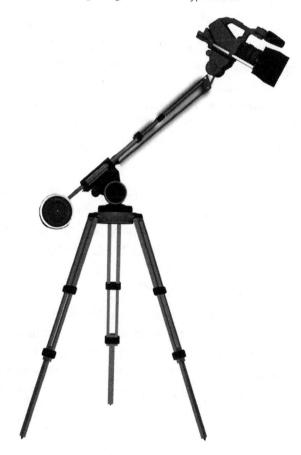

While some jibs have no actual control over the camera other than to make sure the shot stays level during raising or lowering, many jibs have accessories that allow for extra camera functions. Some even hold fully robotic camera heads that can pan and tilt the camera, as well as provide access to zooming and focus.

Camera Stabilization Systems

The first truly effective system for stabilizing a handheld camera was introduced in 1976. Invented by Garret Brown and called the Steadicam, it rapidly became a very useful tool in the motion picture and (subsequently) in the video production business.

This device isolates the operator's movement from the camera, virtually canceling out obvious operator shakes and bumps, and making for an extremely smooth and steady shot, even when the operator is running with the camera (see Figure 2-6).

I was attending the Northwest Film Seminar in Seattle when the Steadicam was making its debut. After watching several clips from Hollywood movies (one of which was *Marathon Man* with Dustin Hoffman) and being wowed by the very smooth-moving shots, Garret Brown came running out on the theater stage wearing the Steadicam rig. He was jogging (and so bouncing up and down as he ran), and the camera was just gliding smoothly in front of him. The entire audience of professional filmmakers let out a collective gasp of amazement! We'd never seen anything like it. It was a very memorable moment.

Since then, there have been dozens (if not hundreds) of devices manufactured that will take the shakes out of handheld shots. Some, like the Glidecam, are similar to the Steadicam. Others, like the Fig Rig, work on a completely different principle, so they look and work quite differently. But the effect is the same—the shots look great.

Other Considerations

There are far too many camera mounts and stabilization systems around to enumerate all of them. Some are specific to a certain situation—like a clamping camera head (sometimes called a hi-hat) that can be attached to a ladder, or a set of "baby legs" (a very short, but substantial, set of tripod legs) to get solid low-angle shots. Others are born on the spot by the mother of all invention: necessity. An example of this

FIGURE 2-6 Camera stabilization rigs bridge the gap between static tripod shots and moving hand-held techniques.

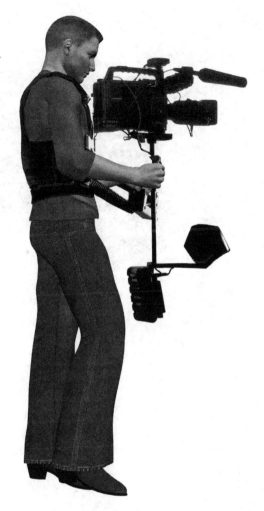

might be cradling your camera in a sand bag, which can be molded to hold the camera at just about any angle (see Figure 2-7).

When a tripod is not conducive to your situation, don't just fall back on a sloppy-looking handheld shot. Be creative!

FIGURE 2-7 A simple method to stabilize your camera

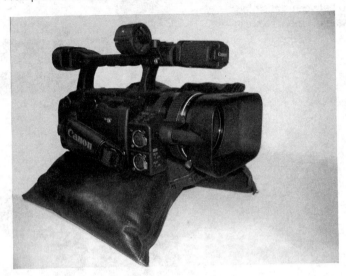

3

Picture Composition

When an audience begins to view your production, the first thing they see (after any opening titles and credits) is how the camera is capturing the subject. If that is done well, the audience will never notice how level the camera is, how smooth the camera moves are, and how well things are composed within the frame. Sad to say, they rarely notice your best work...but they sure will notice if you do it poorly.

Framing and Composition

The objective of this chapter is to give you some hints on how to make your camera work *so* good that the audience will never notice it. Bizarre, isn't it? But, as soon as they notice poor camera work, their attention is drawn away from the story you are telling.

First, let's nail down a couple of definitions:

- **Frame** The screen space used for your presentation, determined during production by the viewfinder boundaries and the space within those boundaries.

- **Composition** The placement of various objects, settings, and characters within those boundaries (the frame).

Centering

Usually you want the composition within the frame to be pleasing, or at least acceptable to the audience. Occasionally, there may be purpose in "upsetting" the composition so that the audience becomes subconsciously uncomfortable, or that they will subconsciously (or even consciously) question why things within the frame are as you present them. This way, they are being asked to figure something out that will help their understanding or enjoyment of the story. Whew! Let's look at some examples, starting with Figure 3-1.

This figure shows a cereal box sitting on a table with no particular background. The box is centered horizontally in the frame. It's almost centered vertically as well, although we expect objects to rest a little lower in the frame because of gravity and head room, which will be discussed later in this chapter. Because there are no other elements in the shot to be included in the composition and the box has no left/right orientation, it is correct that it be centered.

Figure 3-2 shows the cereal box off-center, but because there are still no other subjects in the frame begging for attention, the composition here might be considered wrong.

FIGURE 3-1 An innocent cereal box

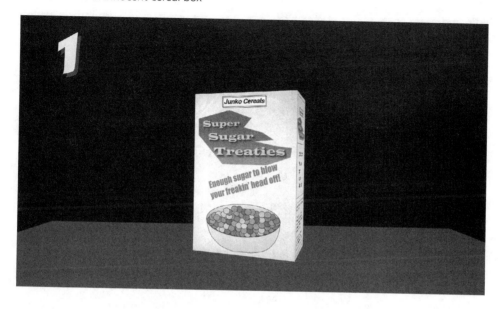

FIGURE 3-2 An inordinate amount of extra space

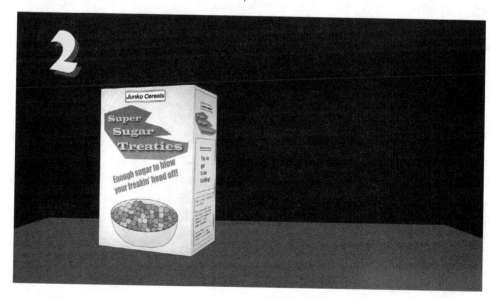

FIGURE 3-3 Here comes trouble!

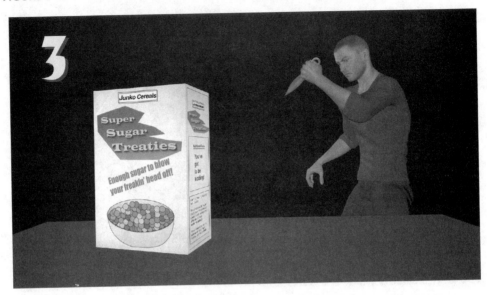

Too much attention is drawn to the empty space to the right of the main, and only, subject. Unless, of course, you want the audience to question the empty space, which leads us to the next picture.

In Figure 3-3 the audience's curiosity about the empty space is rewarded by the introduction of another character. This character creeps into the frame just as the audience is beginning to question the empty space. Yes… it's the dreaded CEREAL KILLER!!! Arrrgh!

Because we've left enough room for the killer to be included in the composition—and we've cunningly crafted the length of our shot to allow the audience just enough time to identify the cereal box and then lock on to the empty space just as the killer enters the frame—the audience will easily be able to see what's happening and have a ringside seat for the mayhem that will occur.

Figure 3-4 shows the last bit of action in our sad little tale as the poor cereal box is done in.

FIGURE 3-4 Send flowers, or better yet, milk and a bit of sugar!

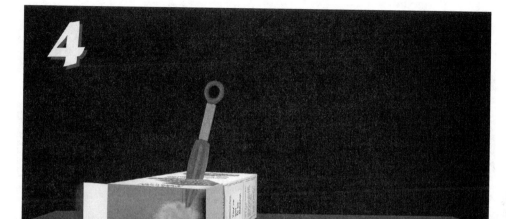

So much for my corny and flakey sense of humor (ouch—who threw that?).

The point here is that a single subject that has no particular left/right orientation and no reason to be off-center should be centered. If, as in our example, there is a reason to upset this traditional framing for the purposes of the story, then go for it. Just be certain that your story is well served by your composition.

Screen Direction

So, does this mean that everything should be centered in the frame unless another element is about to be introduced? That's where screen direction comes into play. The term screen direction has nothing to do with the role of the director of the film. It means the direction that objects, animals, or people appear to be facing, either when stationary or moving on the screen.

Figure 3-5 depicts shots of a man and a woman having a conversation. In each shot the character is placed slightly to one side of center. That is because of the direction each is facing. They are not facing the camera, but are in profile to the camera as they face each other.

FIGURE 3-5 Lead room

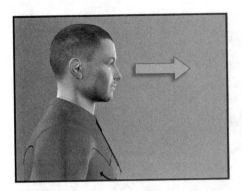 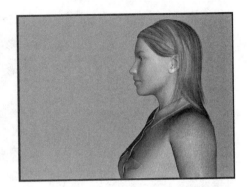

In front of each character is space that is referred to as lead room. Having some lead room in front of the actors seems natural, as their attention is focused beyond the space between them. If they were centered, it might put too much emphasis on the space behind them (unimportant space) because it would be equal to the space in front (important space).

If, during one of these shots, the character turned slowly to the camera to include the audience in the conversation, the camera operator should ease them into the center of the frame. A character facing the camera has no left/right orientation and should be centered.

Figure 3-6 shows another example of a moving subject. Imagine that the camera is mounted on a moving vehicle or camera dolly and we're tracking the subject. The buffer zone isolates the runner from the edge of the frame, but this space is less important than the lead room. As we move along with the subject, the background that enters the frame becomes new information. By the time it gets to the buffer zone, it's old news. This gives the viewer something to look forward to.

Head Room

The term head room literally refers to the amount of space between the top of a person's head and the top of the frame. While head room may vary depending on the field of view (how wide or tight the shot is), in most shots, the head room must be specifically accounted for. We humans don't like to see the top of someone's head cut off, except, perhaps in an extreme close-up where it is unavoidable.

FIGURE 3-6 Buffer zone and lead room

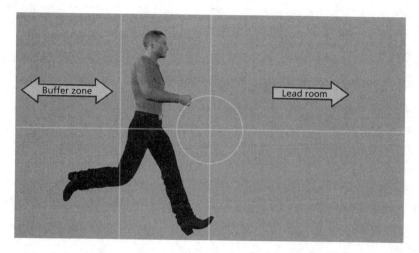

How much head room should be given during any field of view can be easily determined if you follow one simple rule: If you divide the screen into horizontal thirds (usually in your imagination), try to put the person's eyes on or very near the top third line. Figure 3-7 helps make this explanation a little clearer.

Notice that this person has a reasonable enough space above her head that it does not seem as if she is bumping her head on the top of the frame—and neither is there

FIGURE 3-7 A reasonable amount of head room makes for a visually pleasing shot.

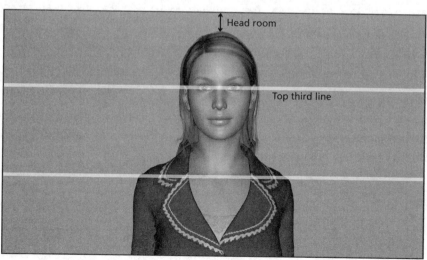

so much room between the top of her head and the upper frame line that it will make the audience question the purpose of the space (just as the extra space afforded to the cereal box in Figure 3-2 did in the cereal killer tragedy).

No matter how wide angle or close up the shot is, if you keep the eyes on that imaginary line, the head room will always be correct for the shot.

As mentioned earlier, an extreme close-up will cause you to have to make a decision as to whether to keep the top of the head or the chin. The shot will just be too tight to accommodate both. The rule of thumb here is to cave in and cut off the top of the head. Why? Well, because while the top of the head is a handy place to hang your hair (if you have any), the chin is actually part of your facial features and is part of what makes you recognizable. Plus, it wags when you speak and so helps people to follow what you say if the sound track isn't perfect.

Remember, head room applies to any shot where human beings are the main component. If there are several people of different heights, etc., you must choose one—presumably the tallest or the most important character in the scene. Beyond that you should also consider head room when your subject is an animal, a vegetable, or even a mineral (dog, flower, rock, etc.), but because these subjects are often quite different in shape than a human being, you are allowed to be very liberal with your interpretation of correct head room for them. Don't have a nervous breakdown over it. Just doing what you feel looks good is usually okay.

Periphery

This last "rule of composition" isn't really a rule at all. It's simply a check that you should always conduct before making your shot. It's a known fact that when viewing a screen, the audience tends to concentrate their attention toward the center of the screen at first and then is led to the subject(s) of most interest by the cunning filmmaker.

As camera operator, you also have a tendency to keep your attention well within the frame, and before you make the shot, you must force yourself to scan around the outer edges of the frame to see if there's anything in the shot that shouldn't be there. Figure 3-8 provides an example.

FIGURE 3-8 Alright, pilgrim. Now that we've framed the shot, let's roll. WRONG!

While we've staged the shot of the saloon interior for our Western movie very well, you will notice several things that really shouldn't be there, things that you could have missed if you'd not taken the time to scan the frame. This means not only looking all around the outer frame, but also carefully considering the whole frame. It's amazing what you might find, as Figure 3-9 shows.

I don't think there's an event videographer on the planet that hasn't deserted their tripod for some great handheld shots only to accidentally shoot a reverse angle and end up shooting a picture of their tripod.

Fields of View

In order to convey the meaning of how wide or close a shot should be, there must be some way of expressing each shot type that might be required. While I have heard of up to a dozen breakdowns between an extreme long (wide) shot and an extreme close-up, it's really only necessary to use about five.

Here are the ones that I've heard (and that I use) most often:

- **Extreme long shot (ELS)** Much more than the subject matter is seen in the frame.
- **Long shot (LS)** The subject matter comfortably fills the frame, with appropriate head room and a little room beneath the subject as well.
- **Medium shot (MS)** Approximately half the subject matter is seen in the frame. Also called a mid-shot.
- **Close-up (CU)** About one third of the subject matter is framed. A classic head and shoulders shot.
- **Extreme close-up (ECU)** One quarter or less of the subject is seen in the frame.

Figure 3-10 shows how these fields of view might look.

It's traditional in the industry to use the abbreviations ELS, LS, MS, CU, and ECU in any documents (scripts, shot lists, etc.). When working with a knowledgeable crew, these abbreviations can be spoken and will be understood (and it sounds real cool). Keep in mind that Figure 3-10 is an *approximation* of how each field should look. There is a little room for your own interpretation, but you should be close to what is depicted here.

FIGURE 3-9 Things you might have missed

Microphone in shot

Someone left a digital camera on the set

Did you notice he's wearing a wristwatch

Electrical cords on the floor

Grip-stand shadow from off-camera

FIGURE 3-10 These are standard definitions of shots.

ELS
(Extreme long shot)

LS
(Long shot)

MS
(Medium shot)

CU
(Close up)

ECU
(Extreme close up)

Cut Off

When we say that in a long shot (LS) the subject comfortably fills the frame, we mean from top to bottom (vertically). With very few exceptions, people are usually not as wide as they are high, so we're not talking horizontally. While we try not to have our subjects interfere with the frame, in any shot tighter than the long shot you will have to start cutting off body parts. It's okay because audiences are quite used to this form of mutilation, but there is a rule to be observed here (of course!). The rule is: *Thou shalt not cut a person off at a natural joint!* Figure 3-11 demonstrates why.

FIGURE 3-11 Good and bad positions for the lower frame line

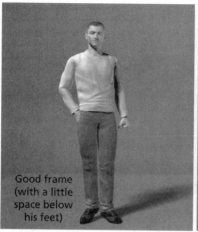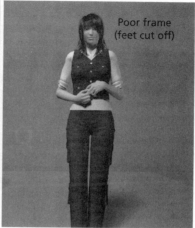

So, in a long-shot composition where you have decided to not show the feet, don't cut the person's feet off right at the ankles. This just looks weird! Similarly, don't cut a person off at the knees, the waistline, or the neck (the worst thing you can do). The elbows don't matter so much because they are not part of the torso and might likely move around a bit anyway.

When you cut a person off right at the neck, it gives a subconscious image of a decapitated head, or a "head in a box" image, that can be uncomfortable for the viewer. In this field of view you could either zoom out a wee bit to include the shoulders or zoom in to an extreme close-up (see Figure 3-12). If you opt for an

FIGURE 3-12 Zooming in or zooming out of a face is preferable to cropping right at the neck.

Not OK
(Head in a box)

OK

OK

extreme close-up, you will have to sacrifice the top of the head (as mentioned earlier). For some reason, showing just the neck and what's left of the head is somehow acceptable. If you really must know why this is, you should get out of filmmaking and take up psychiatry.

The Moving Shot

Unlike a still photograph, the frame in a motion picture shot might be constantly changing and composition will have to be updated constantly. Watch a single shot from a televised hockey game and you'll know what I mean. By utilizing the ability to pan (rotating the camera to "look" right and left), tilt (moving the camera to "look" up and down), and zoom (simulating a move closer or farther from the subject by adjusting the lens optics) you can change the composition as the shot progresses.

To practice this skill take your camera outside on the street and while viewing the opposite side of the street pan smoothly back and forth. Follow car traffic as it passes you one way and then the other. Then find a tall building and practice tilting from bottom to top and from top to bottom. Follow a subject moving from left to right in a tight shot (MS or CU) and then widen out with the zoom as you stop panning. Then catch another subject going the other way and begin the opposite pan to follow it as you zoom in. If you can get permission to film a local sporting event, try to follow the action (hockey would certainly be better than chess). It's all good practice.

The Last Word

Proper framing and composition is a very important aspect of the filmmaking process. Remember, your camera work is the first thing the audience will critique you on. Always think about the composition while setting up and making a shot.

4

Lenses, Light, and 'Lectricity

Modern motion media is composed primarily of pictures and sound. Attaining the highest degree of audience acceptance begins with the right type of visual image, properly displayed.

Capturing a Clear Image

Creating an image for your production requires some light on the subject and the right lens to pass the image through to the camera.

Lenses

In the early days of photography and motion pictures, there was only one lens to a camera (see Figure 4-1). If you wanted to switch from a standard field lens to a telephoto lens, you would have to unscrew one lens and replace it with the other while the camera was not rolling.

Then a new level of sophistication was reached with the invention of the lens turret, a rotating plate mounted on the front of the camera that held three or four lenses, which could be rotated into place as required, again, as the camera was at rest (see Figure 4-2).

FIGURE 4-1 Silent movie camera with fixed lens.

FIGURE 4-2 The lens turret partially rotated for clarity.

Finally, along came the zoom lens (see Figures 4-3 and 4-4). A single lens could now be used to shoot wide-angle, normal view, or telephoto shots without having to actually change lenses.

The original zoom lenses were not optically sophisticated enough to actually use the zoom function during the shot. A lot of optical distortion would be evident during a zoom move due to the number of glass elements in these lenses. Eventually, lenses were made to higher specifications that minimized this distortion. The field of view could now be adjusted during the shot, a special effect that draws the audience in for a closer view of the subject or pushes them away to give a wider shot. Unfortunately, many filmmakers went zoom-crazy. Ten or twelve fast zooms in rapid succession can make some audience members feel queasy, and the rest of us just annoyed. If you want to zoom during a shot, it is acceptable, but do so sparingly.

FIGURE 4-3 The zoom lens. Notice the caps on the turret where other prime lenses would be. With the zoom lens we don't need them.

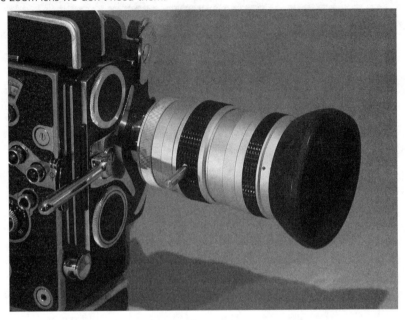

FIGURE 4-4 Cut-away view of a zoom lens showing the many glass elements.

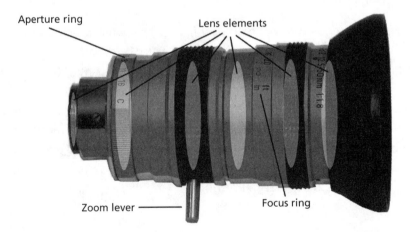

Fields of View

Before learning what "fields of view" is all about, it's important to understand what the focal length of a lens is. You might have heard someone asking what length of lens was used on a particular shot. This sounds as if there is an important fact about the actual length along the outside of the lens, from the camera body to the end of the lens. This is not what lens length means.

As Figure 4-5 indicates, focal length is the distance between the optical center of the lens, when it is focused on infinity, and the image plane. In a video camera, this is the charged coupled device (CCD) (in a single-CCD camera) or the prism that breaks the light into three beams to be passed on to each of three CCDs in a three-CCD camera. The CCD is an electronic device that converts the light into an electrical signal to be recorded on the capture format (tape, static memory, hard drive, etc.).

The measurement, which has been created by the manufacturer when engineering the lens, is based on the way light is treated as the lens is being focused. Most lenses allow a focus range from just a few feet (or meters) in front of the camera to 50 or more feet (15.24 meters), as well as a last setting for infinity, which means that everything will be in focus from 50 feet to infinity. An example of an infinity focus setting would be when you are shooting mountains in the distance (or anything else further than 50 feet away).

FIGURE 4-5 Focal length

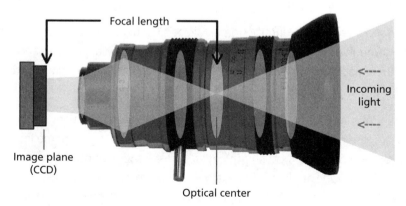

Light reflected from your scene into the lens will be inverted at a certain point and then sent on to the CCD(s), much as happens with your own eyes—the brain then rights the image for you so you don't feel you're living in a topsy-turvy world.

As you focus the lens from, say, 3 feet (0.9 m) through 50 feet and on to infinity (and beyond!), the optical center, where the light inverts, shifts from lens element to lens element, finally coming to rest in only one element. The measurement is taken from this element (the optical center) to the image plane in the camera. It is expressed in millimeters.

So, for instance, you might have a 12mm lens, a 50mm lens, or a 75mm lens for your camera. In 35mm photography (still or motion picture), a 50mm lens is called a normal lens because it most closely represents an image that is not magnified, much as you see with your naked eye. A normal lens for a video camera depends on the size of the image sensor (CCD). For a quarter-inch CCD, 5.2mm is normal; for a one-third-inch CCD, 6.5mm is normal; and for a half-inch CCD, 9.3mm is normal.

If a normal lens is 6.5mm, then any lens less than this is considered to be a wide angle lens, and a lens above this measurement is considered to be a telephoto lens. Figure 4-6 shows the field of view you might expect of each of these lenses.

As you can see, the distance between the camera and the subject (called focal distance) is the same in each example. Because of the lens distortion in the wide angle and telephoto examples, the subject appears to be either farther or closer to the camera and more or less of the background is seen.

Telephoto shots are like looking though a pair of binoculars. The subject is magnified. The view through a wide angle lens is like turning the binoculars around and looking through them backwards. It appears to push the subject away optically. If you've never tried this with binoculars, try it and you'll see a wide angle view of your scene.

Although 12mm and 75mm are standard focal lengths found on many inexpensive zoom lenses, the range can be far greater on many zoom lenses or prime lenses (lenses that have only one focal length). Wide angle lenses can go down to as little as 6mm. A 6mm, wide angle lens is usually called a fish eye lens because the optical distortion makes very close objects appear to bend into a round shape. This effect is

FIGURE 4-6 The field of view from three different focal lengths

Telephoto

Normal

Wide angle

often used for artistic shots. An example might be a shot from the point of view of a drugged patient in a hospital as the doctor leans close to examine him or her. The doctor's face will be distorted in such a way that his face will become roundly distorted—a great effect to create a feeling of disorientation (see Figure 4-7).

The reason it's called a fish eye lens is that a fish's eyes usually protrude from the head so that most of the eye surface is available for image capture. It is supposed that a fish can see almost 180 degrees—a very wide angle indeed.

The use of a good quality lens, either prime or zoom, will ensure that you have the ability to obtain the sharpest, most high-quality images with a minimum of unwanted distortion.

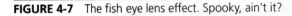

FIGURE 4-7 The fish eye lens effect. Spooky, ain't it?

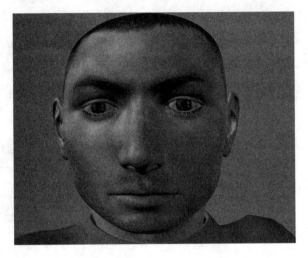

Lighting

The use of proper lighting technology and techniques will set your program apart from amateur productions.

Why Light?

With today's sophisticated video cameras that work well in very low light (let's not even talk about night vision or infrared photography!), why would we want to light a scene? Here are a few important reasons:

- To illuminate the scene so that imaging is possible
- To bring out proper contrast ratios between the lightest lights and the darkest darks
- To bring out proper color shades and intensities
- To model the subject pleasingly

In the early days of filmmaking (1890s through 1920s) most motion pictures were shot outdoors. The reason for this is that until around 1928 there were no electric lights bright enough—or film speed fast enough—to capture good, natural-looking images.

The technology simply wasn't there to allow shooting indoors. Obviously, there had to be enough light to capture a proper exposure on the film.

What is exposure? Here's a definition: Exposure is the manipulation of light to create a picture with proper contrast density and color, or just contrast in black-and-white filming, that resembles reality. Eventually, new, larger wattage lights were made and film sensitivities were formulated to shoot under these new light sources.

The desire to shoot indoors was pressing for many reasons. First, when shooting indoors, the filmmakers had control over the elements. Shooting would no longer be subject to weather conditions or costly outdoor set construction. However, when the filmmakers first moved inside and screwed one of these new, higher-intensity lights into a ceiling receptacle, they found that the lighting on their actors looked very poor on film. They tended to look flat and "pasty"—in other words, two dimensional. Remember, the screen on which we show this picture will only represent two dimensions: height and width. We have to try to simulate the third dimension (depth) using light and shadow. We do this much the way an artist would draw a sphere (see Figure 4-8).

The artist would start out drawing a circle, which, if left as a circle, could be envisioned as a disk, like a flat coin. But, by utilizing shading—shadow and light in the photographic sense—the artist can turn that image into the *likeness* of a sphere. It's all a trick to make your brain think it's seeing a third dimension that doesn't really exist on the paper.

FIGURE 4-8 First, I drew the flat circle on the left and then I shaded it to create the sphere.

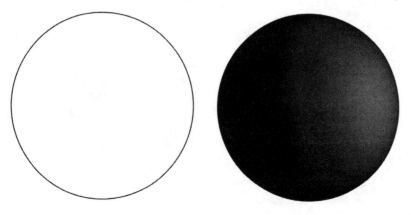

So, obviously, formulas for lighting had to be concocted that would simulate the three-dimensional look that daylight can give, or any other type of lighting required. While the sun is earth's single actual light source, as it passes through our atmosphere, the light scatters and reflects from many objects on the ground. This can give a sense of lighting coming from several different directions. The greatest amount of light comes from the direction of the sun in the sky, but other lighting is reflected from rocks, trees, buildings, etc.

Three-point Lighting

So, lighting became a dedicated technological art form in photography. The first level of professional lighting is the three-point lighting formula (see Figure 4-9). This formula is intended, first and foremost, to make a single actor look their best. That beautiful "magazine cover model" look.

In the plan-view diagram, the camera and subject positions are predetermined and then the three light sources are placed.

FIGURE 4-9 Three-point lighting setup. The intensity of the lights is a 2 to 1 ratio.

Back light (2)
(*Example: 300 foot candles*)

Fill light (1)
(*Example: 150 foot candles*)

Key light (2)
(*Example: 300 foot candles*)

The *key light* is the fixture that will play the part of the sun. Note that the key light is not right over the camera. This would give a flat, two-dimensional look to the subject, and so it is set off to either side of the camera. This light will be very bright and harsh. The bulb may be clear (you can see the filament though a clear glass envelope) and will cast a very well-defined shadow of the subject onto the background.

The next light is the *fill light*. Either a frosted bulb or diffusion material will be used to soften this light. Its dispersion pattern will likely be quite wide. The fill light will provide approximately half the intensity of the key light and will soften shadows on the side of the subject that it is affecting. If this is the only light on, it will cast a very hazy shadow.

The last light is the *back light*. The back light is not meant to light the back of the subject. When the camera is in front of the subject, that would be just silly! It's meant to cast a rim of light on the top of the head and the tops of the shoulders. If your subject has, for instance, dark hair, a dark shirt, and is standing in front of a dark background, they will tend to blend into the background even though they may be several feet in front of it. That rim of light—the back light—will "pop" them out or separate them from the background. It is usually the same intensity as the key light.

Typically, the key light is quite high up on its stand or in the overhead lighting grid. The fill light will usually be lower, perhaps two-thirds the height of the key light. The back light will be the highest light because it is over and slightly behind the performer and so is in camera view if it is not high enough to be out of frame. The chance of a lens flare from this light is also a consideration even if the light is above the top of the frame, so the higher it is hung, the less chance of this there is. A stand is often not possible for a back light, as it would show up behind the performer, so it's usually hung in an overhead lighting grid or clamped to an existing ceiling fixture.

Figures 4-10 through 4-16 illustrate key light, fill light, and back light in action.

FIGURE 4-10 Victoria is in silhouette because only the background is lit.

FIGURE 4-11 We've begun staging our three lights. Only the key light is turned on.

FIGURE 4-12 The fill light is very soft and half the intensity of the key light.

FIGURE 4-13 The back light is the same intensity as the key light, but only rims the top surfaces.

FIGURE 4-14 Here is Victoria with all three lights on and balanced to their 2 to 1 intensity levels.

FIGURE 4-15 Ever hold a flashlight under your chin to scare your little brother?

FIGURE 4-16 Flat lighting often used for wide shots

Broadcast Lighting

Broadcast lighting here does not refer to lighting for television, but rather the practice of quickly (and in most cases very effectively) lighting a wide area with several lights of the same intensity. These lights are typically lined up on either side of the camera and spaced equally across the width of the set for even lighting from one side of the set to the other.

In order to get the intensity correct across the entire set, a "reflective" light meter is used that can be pointed at the set to read the total amount of light that's reflected back. An "incident" light meter is one that reads the light intensity from a single light source by pointing the meter directly at the light. We don't need that type of light meter here, although some meters will perform both functions (see Figure 4-17). With broadcast lighting, the director of photography (DOP) will walk slowly back and forth across the width of the set to make sure that the lighting is even (see Figure 4-18).

Triangle Lighting

Triangle lighting is a very quick way of assuring key/fill lighting ratios when working without the aid of a light meter. It does not take into account the back light, and while we should try to get the back light to the same intensity as the key light, it is more or less a dress light anyway, so it can be set by eye.

FIGURE 4-17 My old Sekonic Studio Light Meter. It works as both a reflective and an incident meter.

Here's an example scenario: You are the DOP for a documentary crew asked to do an interview of a prominent politician who is staying at a local hotel. The hotel has graciously allowed you to set up minimum equipment in one corner of their lobby where there is a comfortable chair that your interviewee (the politician) can sit in while being grilled by your off-camera interviewer. You can set up a key and fill light for the politician, but a back light is not practical because the chair is against the wall and there is no room to set it up to reasonable advantage. Besides, the chair and the wall behind it provide enough contrast.

FIGURE 4-18 Broadcast lighting setup

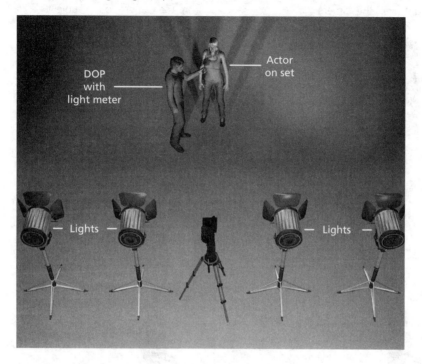

How do you ensure proper key light to fill light ratios? Simple. You use the triangle lighting formula. One proviso here: You must use two light sources that give off exactly the same amount of light. Figures 4-19 through 4-24 illustrate how the triangle lighting formula works.

It's very quick and easy to set up and can come in handy. If you just do it by eye, other crew members on the set will be amazed at how you could be so accurate when it seems that you just casually placed the lights and created perfect lighting! Wow!

No matter how you do it, it's very important to get the right lighting effect on individuals and tight, small group shots. Much of this type of lighting is done by careful placement, reading intensities, and experimentation.

FIGURE 4-19 Step 1: Set up a light near (but not right over) the camera.

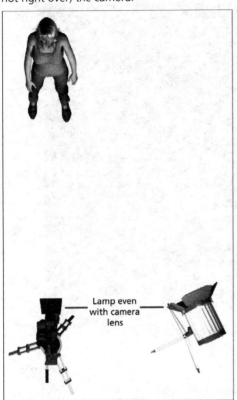

Lamp even with camera lens

FIGURE 4-20 Step 2: Pace out the distance from the camera to the subject.

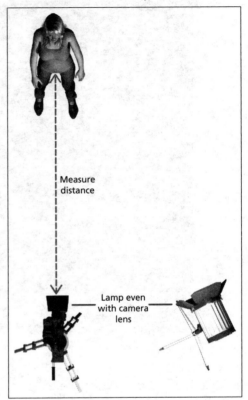

Measure distance

Lamp even with camera lens

FIGURE 4-21 Step 3: Measure the same distance 90 degrees away from the light you've set up.

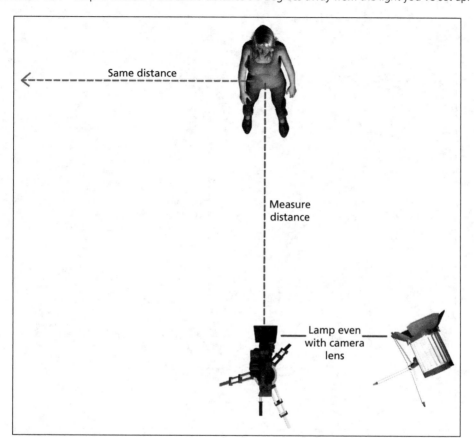

FIGURE 4-22 Step 4: Sight a straight line back to the camera.

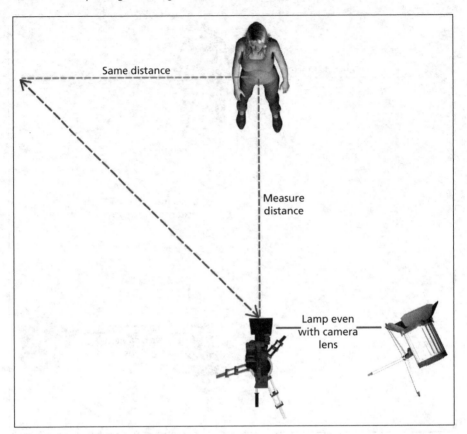

FIGURE 4-23 Step 5: Plant the second light at the halfway point of this line.

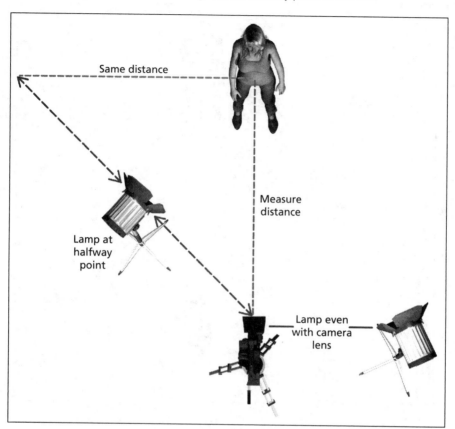

FIGURE 4-24 The key light will be the one closer to the subject. This can all be done by eye.

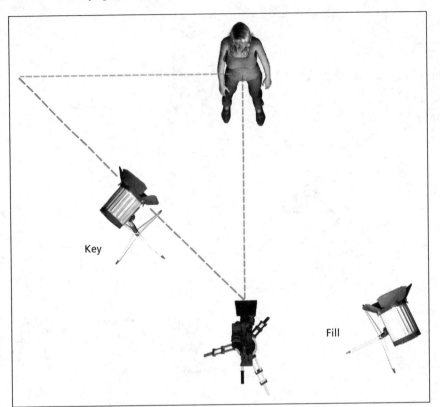

Lighting Products and Objects

Lighting the people who appear in front of your camera is important, but you will likely be called upon to properly light other things as well. Figure 4-25 indicates just a few pieces of extra lighting gear that you can use to paint your setting with light. In this figure, the gel frame is slotted into the lighting fixture and can hold colored gel, diffusion material, or a wire mesh screen to lower the light intensity. The barn doors on the light help it from falling where it's not wanted. The French flag held in the grip stand will block light from a distance in front of the light when the barn doors cannot do the job properly.

FIGURE 4-25 Lighting equipment

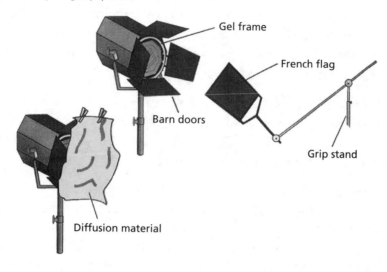

Electrics

Artificial light requires electricity. It's important to know some basic electrical theory and safety considerations.

Current Consumption

By now, you might be getting the idea that we tend to use a lot of light to create the look that we want in a scene. On a small shoot, you might utilize a lighting kit with three or four fixtures. Each of these might have a bulb with a wattage rating of 250 to 1000 watts. This is a very conservative lighting kit for interviews or small area coverage. If you can't afford to buy a good kit, you can always rent one for a reasonable day rate. A larger shoot covering a larger setting might utilize the equivalent of several of these kits and single lighting fixtures up to 2,000 watts each or more.

A Real-world Example

You've been asked to shoot in an office or factory setting, mostly around one desk or work area. You have a 1,000-watt lamp and two 600-watt lamps. You've determined that these will provide enough light for the setting, but you aren't sure how many lights you can plug into one outlet before tripping a circuit breaker and possibly causing a problem for the office or factory workers. In order to avoid this situation, you have to do a little research and be aware of a simple mathematical formula.

The research part is finding out what else may be plugged into the same circuit. Any given electrical outlet might be joined to several other outlets that are on the same circuit. Outlets on the same circuit are usually (but not always) on the same wall. Outlets on opposite walls are usually (but not always) on separate circuits. Unfortunately, there are always exceptions, especially in renovated buildings.

Also, just because all of the outlets on one wall are not being used doesn't mean that there aren't outlets on the other side of the wall that are on the same circuit. You just have to look for things that could likely be on the circuit you want to use and factor them into the math. It's not really an exact science.

If you find there is a cell phone charger plugged in, or maybe a small desktop clock, don't worry about it. These small, solid-state devices will not draw enough current to affect your math, unless you find 50 such devices on the same circuit. If, on the other hand, you find anything with a motor in it (refrigerator, air conditioner, desk fan, etc.) or a cathode ray tube (CRT) television or monitor, you definitely have to find out the current draw (wattage) of these devices and factor them in. It is probably a good idea to either unplug them if you can or use another circuit for your lights.

A Lesson in Electrical Theory

The purpose of this book is not to educate you in depth about subjects that are not video production techniques, but occasionally I feel compelled to make sure you understand at least the basics so that your production life is made easier. So, here's the short course on what you need to know about things electrical (don't worry—it's short).

First, some definitions:

- **Electricity** The flow of electrons.
- **Voltage, volts** A measure of the pressure under which electricity flows.
- **Amperage, amps** A measure of the amount of electric current.
- **Wattage, watts** A measure of the amount of work done by a certain amount (or amperage) of electric current at a certain pressure or voltage.

Okay, now that you have these definitions, how do you use them? Let's say you set up to shoot an interview in someone's corporate office and you have a light kit consisting of two 1,000-watt lamps and two 600-watt lamps. When you start looking for power for these lights, you find that the small office only has two outlets. These are on

opposite walls, so are probably separate circuits. The most convenient way to provide lighting would be to plug both 1,000-watt lamps into the same outlet. Can you do this without blowing a breaker?

Before we do the (simple) math on this, you have to know certain facts: North American power is 110 to 120 volts and most outlets are 15 amps. Since you already know the wattage of your lamps (which you should make a point of knowing), you are ready for the calculation. It is:

Total wattage of lamps divided by voltage of power supply = amperage required

If the answer exceeds 15 amps, then you cannot do it. For instance, two 1,000-watt lamps equal 2,000 watts. So:

2000 / 120 = 16.66 amps. If you divide by 110, the answer is even worse (18.18 amps).

In short, you can't plug two 1,000-watt lamps into the same receptacle without tripping a breaker. You'd be better off plugging one 1,000-watt lamp and one 600-watt lamp into each receptacle (1600 / 110 = 14.54 amps).

Important Safety Tips

It's been suggested by my editor that I include some safety tips concerning the use of electrical lighting. My experience is that if anything can go wrong on a set, it will most likely be with the lighting. Either you work for hours and can't quite get the look you want (although that's not really a safety issue, unless you consider the temperament of the director) or you might have an electrical or heat problem.

So, here are some general safety tips:

- When first setting up light stands, use a double-sided sandbag to hold the stand upright. Some lighting stands and fixtures are very lightweight and could easily be knocked over. A double-sided sandbag is a single bag, stitched through the center so that it will hang on the stand. Do not allow this bag to touch the floor, or it will not hold the stand effectively!

- When you set up your lights, and before you plug them into a power source, always make sure that the switches on the lights are in the *off* position. This will assure that the light will not come on when you plug it in and blind someone on the set who isn't expecting the brilliant, sudden light. It also negates the possibility of an electrical flash at the plug, which could burn you.

- Bulbs can explode when their life is over (talk about going out in a blaze of glory!). So don't stand too close to a lamp that's powered up. If possible, use screens in your light fixtures to stop glass from flying outward. I was working in a television studio when an exploding bulb showered the host with glass. Fortunately, he wasn't hurt—just covered in hot glass—but it could have been devastating.

- Another thing that can cause a bulb to blow up is by touching it with your fingers, likely when you're changing bulbs. The oil from your skin will transfer to the bulb and when the bulb is turned on, it will heat up unevenly and explode. This only happens on bulbs that are in the upper wattage range (500 watts or more).

- When handling hot light fixtures (for example, when you adjust the barn doors), always wear protective gloves.

- If you are moving lights between shots, always unplug the cord first. Don't drag the extension cord after the fixture. It could pull tight and cause your stand to fall over when you put it down before you replace the sand bag on it.

- Inspect your electrical cords regularly and service them if they seem the least bit frayed.

Lighting your scene properly allows you to achieve a look and feel that is specific to your subject. It's worth spending time to get just the right visual effect.

5

Production Audio

Another important component of a video/film production is the sound. While on-set sound recording sometimes takes a back seat to capturing images, a poorly recorded soundtrack can detract significantly from the production values.

On-set Audio Recording

The lead sound technician must be well versed in both the physical elements used to record sound and the proper techniques to ensure high quality.

Introduction

The last chapter on lenses, lighting, and electrical theory was jam-packed with information. This chapter on audio recording will not be as long, not because recording the audio is less important than lighting the set and capturing the image, but because there really is less to learn in order to produce good quality audio.

Now that I've said this, sound is an essential element of any production. You can have the best camera work, direction, acting, lighting, etc., and it will all be for nothing if your sound quality is not top-notch. Also, a lot of what we do with audio is done in post-production. It's created or acquired in post-production, or manipulated to finish off the sound track of the video during editing. More will be said about post-production audio later in this book.

Audio during the production stage basically involves getting your microphone(s) out there where the sound is and recording it. We don't (usually) record the background music or sound effects during the production stage. We just record what is being said by the on-camera actors or standup announcers and capture the sounds that happen normally in the location environment.

Some filmmakers rely on the microphone built into the camera to capture most (or all) of their location sound track. This may be fine if your location sound will only consist of the natural, ambient sounds that occur at the location (voice-over to be added later), but if you want good quality sound, especially of people talking, you will need an external microphone. If you are using a professional camera, there will usually be two low-impedance XLR-type plugs on the camera that can accept an external microphone (mic) input (see Figure 5-1).

If you are using a consumer camcorder, you will have (hopefully) followed the advice in Chapter 2 and purchased a camcorder with a mic input. This will usually be a high-impedance mini phone plug (see Figure 5-2).

FIGURE 5-1 Channel 1 and channel 2 XLR mic inputs

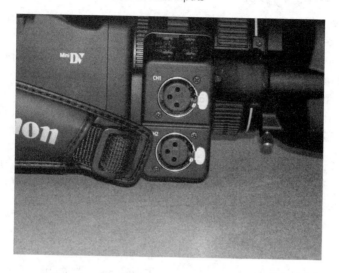

FIGURE 5-2 High-impedance mini phone mic input

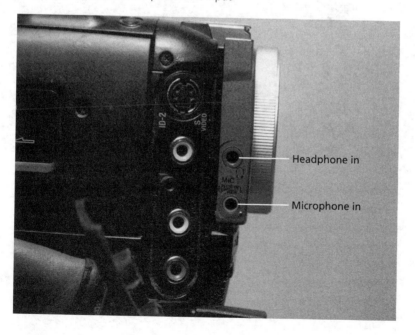

Headphone in

Microphone in

Microphone Types

There are several types of microphones that you can choose from. High-impedance microphones tend to be less expensive but will not support very long runs of mic cable before the signal drops off. These types of microphones do not come in the diversity of pick-up patterns and versatility as do the low-impedance microphones. Low-impedance microphones are the more professional, better quality, and costly type of mic, and while they can be adapted to work in the high-impedance inputs, they are usually used with the more professional cameras.

A sound technician on a video or film set will often employ either a very good hand mic (Figure 5-3) or a shotgun mic (Figure 5-4) for dialog sequences. Sometimes a lapel mic (also called a lavalier mic) is used (Figure 5-5).

FIGURE 5-3 Standard hand mic

FIGURE 5-4 Shotgun mic

FIGURE 5-5 Wireless lavalier (lapel) mic and receiver

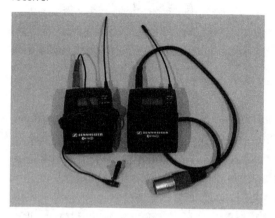

Pick-up Patterns

The shotgun mic has the advantage of being able to pick up sound from a number of feet away without too much ambient sound or echo coming into the sound track. This is because of its pick-up pattern. The pick-up pattern of a microphone is simply the direction(s) from which that mic will pick up sound. There are several patterns, as shown in Figure 5-6.

The type of mic you use may be dictated by the pick-up pattern you wish to have. The omnidirectional microphone will pick up sounds equally from all directions. The bidirectional microphone picks up sound from two opposing directions equally. Cardioid, hyper-cardioid, and shotgun microphones pick up sound from mostly one direction. These are called unidirectional microphones.

FIGURE 5-6 The patterns by which microphones pick up sound

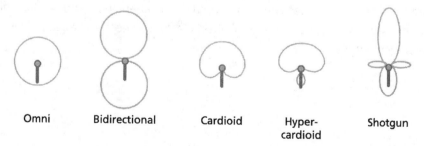

Omni Bidirectional Cardioid Hyper- Shotgun
 cardioid

Microphone Placement

In the early days of film sound, microphones were hidden in strategic parts of the set. The actors' movements through the set during a take would be choreographed so that they were always near a microphone when delivering lines ("Be sure to talk toward the potted plant."). These days, microphones are much more sensitive and can follow the actors around the set in a couple of ways.

The most common way to record actors speaking is by using a shotgun mic on a boom pole (also called a fish pole). With practice and cooperation between the camera operator and the person manipulating the boom, the microphone can swing from one actor to the next and move around in the set without being seen on camera. That's because it is suspended above the actors, outside the top of the frame. On a closer shot, the mic can be below the bottom of the frame, pointing up at the actor's mouth.

If, however, the actors are moving continuously, and perhaps even turning their backs to the camera, often the best solution to ensure consistent sound is to conceal wireless microphones on the actors. The wireless lapel microphone is concealed inside the actor's clothing in such a way that the sound is clear and the clothing will not rub against it. This microphone includes a transmitter box, which can be hidden easily in a pocket. At the camera end, a receiver box is connected to the camera. These wireless microphones can be tuned to different frequencies so that several can be used on the set at once.

Other Sound Equipment Accessories

If you are using more than two microphones at once, you obviously cannot plug all of them into the camera, as the camera only has two inputs. In this case you will need a mixer. There are hundreds (if not thousands) of mixers you can get to accommodate as many sound inputs as you wish. Some mixers are battery operated for field use (Figure 5-7), but larger ones with more inputs and capabilities (equalization of the sound, several output feeds, special effects, etc.) may need to be plugged into house or generator power (Figure 5-8).

FIGURE 5-7 Battery-operated field mixer

FIGURE 5-8 Small studio mixer

FIGURE 5-9 Foam sock on shotgun mic

Other accessories include a sound baffle for the microphone, which keeps wind that blows on the microphone from making an unwanted noise. The foam type used is often called a sock and is just a piece of foam rubber, shaped to the microphone and hollowed so that the mic fits inside of it, as shown in Figure 5-9.

Another baffle for a shotgun mic is a hollow cage, shaped like a zeppelin (Figure 5-10). For obvious reasons, it's referred to as a blimp (see Figure 5-11).

FIGURE 5-10 Graf Zeppelin

FIGURE 5-11 Mic blimp. See the similarity?

A well-equipped sound engineer will be able to supply a battery of support equipment, from mixers to acoustic treatments for the set, and from microphone supports (boom poles, mic stands, etc.) to cables and wireless systems (and yes, even batteries).

The Recording Process

Prior to a shot being made that utilizes a boom pole and microphone to capture the sound, the camera operator and boom operator should rehearse to ensure that the camera will never see the microphone, the boom pole, the boom operator, or an unwanted shadow. When the director (or first assistant director, also called first AD) calls for the camera to roll on the shot, the boom operator must synchronize his boom movements with both the actor's and the camera's movements to acquire the best sound without being seen. To ensure that the recorded sound is clear and free of pops, clicks, hums, etc., the operator should wear good quality headphones, which feed the sound being recorded. When the shot finishes ("Cut!"), both the camera and the sound person will be asked, "Good for camera?" and "Good for sound?" If either had a problem with their part in the shot, they must say so now so that another take can be made. Otherwise, it's "Let's move on!"

Recording Room Tone

Before the shooting leaves a particular setting, or if the normal background sound in a setting changes in any way, some room tone must be recorded. The reason for this is that during the editing process, should the editor decide to drop the sound out of a recorded shot, he or she will have that normal, clean, ambient background sound, free of any dialogue, to put into the "hole" in the soundtrack.

Let me give you an example: We're shooting in an office. The normal background sounds are primarily the air conditioning in the building with maybe a dash of traffic noise from the street just outside the window. Two actors are engaged in a dialog, but during a pause in the speaking, the boom taps one of the overhead lighting fixtures and causes an unwanted sound on the sound track. As neither actor was speaking at just that precise moment, it's an easy job for the editor to just snip that bit of audio from the sound track. But, the air conditioner/traffic sounds will go too (it's usually impossible to separate just one noise from a mixture of sounds). This leaves a silent "hole" in the track. The audience will start checking their hearing aids.

If room tone has been recorded, a piece of it can be plopped into the quiet space and the audience will never be aware that a repair job has been done on the sound track (and won't be worried about the warranty having expired on their hearing aids).

So, before leaving a setting (location or set), or when background sound changes (the air conditioner shuts off or rush hour has commenced), the sound technician should request a room tone recording. This is handled just like a regular shot, with all the proper commands, but there is no dialog and no sounds that don't normally occur (just the air conditioner and the traffic in this example). The camera is pointed at nothing in particular (maybe a slate with the words "ROOM TONE" written on it) and everyone stays completely still and quiet.

It's only important that the microphone be pointed in roughly the same direction as during the shoot if the camera's on-board microphone is being used. This audio is recorded for at least 30 seconds, or often as long as a minute, to ensure that the editor has lots of background sound with any variations that might likely occur in it. This is important because it's really tough for the editor to steal a second here and a second there from between the actors' lines and piece them all together to fill a five-second gap.

When everyone wants to go home after a long day and they start packing up, nothing is more annoying than hearing that they have to stand still for a full minute to record room tone ("Aw, c'mon, man, it's already rush hour!"), but it's really, really important.

As mentioned at the beginning of this chapter, the sound you record on set is a very important component of the finished production. So take your time, listen to the playbacks as critically as you watch them, and reshoot to improve audio whenever necessary. Any weak link in the chain of elements will degrade your final product. Good sound is very important!

6

The Three Stages of Production

There are three distinct processes that need to be accomplished before your masterpiece is introduced to the audience as a finished program. A successful project must be well planned, properly shot, and masterfully edited. Each of these steps comprises a distinct stage of the full production process.

The Production Process

Each of the three production stages is a well-defined, stand-alone process that is the responsibility of people who specialize in that particular stage, and is overseen by the director (who is responsible for all stages).

The Three Stages

The creation of a film or video project includes:

- Pre-production (the planning stage)
- Production (the shooting stage)
- Post-production (the editing stage)

The amount of time spent on each stage is significant. As you will see, though, we usually don't spend exactly one-third of the full project time on each stage.

While none of these estimated times are carved in stone for each project, we might expect to spend approximately 35 percent of the full project time on pre-production. That may seem reasonable if we realize that there are three stages, but it really is a large amount of time compared to the production stage.

The production stage encompasses the work that we see in our mind's eye when we think about filmmaking. Lights, cameras, actors, sets, and locations! Oh, it's all so exciting and so visual! But it really is the shortest amount of time spent on any of the three stages, only about 15 percent of the full project time. Why? Because production is expensive! You have to rent all of that equipment, hire significant numbers of cast and crew, and perhaps even rent locations, pay for travel and accommodations, etc. So it really behooves us to plan carefully in the pre-production stage so that we can shoot efficiently and economically in the production stage.

Last is the post-production stage. We might take up as much as 50 percent of the total time available in our budget on this stage. Why is this? Simply because this stage should not be rushed. It's where all of the creative work happens. Good planning in the pre-production stage helps to ensure that sufficient raw footage of reasonable quality is obtained for the post-production stage, where it is carved, molded, and painted in a fully artistic endeavor called editing. Fortunately, the number of paid crew members is considerably less in this stage than in the production stage. There are usually just one, two, or a handful of people plus the cost of the editing facility.

Now, let's back up and define exactly what happens in each of these three stages.

Pre-production

In the pre-production stage, several tasks must be performed before grabbing your camera and beginning to shoot. If your program is to turn out the way you want it—and it is more than five shots long—it will require some detailed planning in order for the production flow to happen smoothly, and so that all of the material you need to edit gets into your finished program.

Here are some of the steps you will take:

1. Create the planning paperwork that is specific to the production of your project. This includes writing a script, breaking it down into a shot list or scene list, and creating a shooting schedule. More on these documents later.

2. Choose locations in which to shoot, perhaps even booking time in a studio. When choosing a location, several factors enter into its suitability as a shooting site. These include

 - Availability on the planned shooting day(s)
 - Permissions to use the location
 - Camera positions and background views

3. Study the lighting, especially in an exterior location (how much light and which direction it comes from at different times of the day).

4. Employ audio restraints (if recording live audio, is the location too close to traffic or other unwanted noise?).

5. If your location is indoors, check to make sure there is enough available power and room for camera equipment, lighting, crew, audio, etc.

6. Prehire your cast and crew. Even though your shooting day(s) are in the future, you should contact and hire the people you want to work with early to avoid conflicts with their other work schedules.

7. Prebook equipment and post facilities. Much of your equipment may need to be rented for the shooting day(s), and by reserving it ahead of time you minimize the risk of it being unavailable when you need it. The same goes for the editing suite and other outside post-production services you may need.

8. Last, there's the bits and pieces:

- Any travel and accommodations are preplanned and booked.
- Legal documents (contracts, agreements, and release forms) are drawn up.
- Insurance (equipment and liability) and carnets are obtained if you are traveling outside of your home country. Carnets are international import documents that allow you to bring equipment to a foreign location and that you are bound by law to take away with you when you leave.

Whew! That's a lot to take care of. It's why the pre-production stage is so important. You may or may not have to attend to all of these suggested tasks, or there may be a mountain of other tasks ahead of you that haven't been listed here. It really depends on the size and complexity of your production.

Before we continue, it might be a good idea to define the written documents mentioned in Step 1:

- **Script** The text of a play, broadcast, or movie. It describes the program content scene by scene and explains characters, settings, actions, and dialog.
- **Shot list or scene list** The script broken down into individual shots: shot numbers, the visual components of each shot (actors, important props, and settings), the actions that the actors will perform, the camera view and moves during the shot, the on-set sound to be recorded, and an approximate time the usable action of each shot should take.

- **Shooting schedule** A document that includes information of all the scenes to be shot on a given shooting day, the order in which they will be shot and at what approximate time of day, where they are to be shot, what time of day they are to represent in the story, whether they are exterior or interior shots, what characters are represented, what actors and crew members are to be where and at what time, and what equipment is to be at what shooting location and at what time.

Production

The production stage is the stage where you go out and have all the fun of shooting. Right? Well, almost. While there aren't as many tasks as there may be in pre-production, there are still a few to specifically tackle. One of the important points of good pre-production planning is to minimize the amount of work you must do (and money you must spend) in the production stage.

Here's the (short) list:

1. Direct any on-camera talent in what they must do when the camera rolls.

2. Shoot all of the visuals listed in the script and/or shot list.

3. Reshoot where necessary.

Wow! That seems simple. Remember, the goal here is to get in, shoot what you need, pay off the talent and crew, and get out as quickly as possible. This saves not only time, but money.

Of course, it isn't all a whirlwind of activity, robotically performed to the dictates of the script. There are pockets of creativity, script changes that must be figured out on the set, and slow-downs governed by outside forces. For instance:

- The director of photography (DOP) may try out various filters and lighting options because these cannot easily be predetermined until he or she is on set.
- The director will likely want to position the actors and cameras (called "blocking") during the production stage.

- The script may need to be changed (for whatever reason). The rewrite will have to take into account material that has already been shot as well as material that may not have been shot yet but that will need to conform to whatever is rewritten.

- The weather does not cooperate (I once sat around for six hours waiting for the clouds to clear on a television shoot so that our next shots would work with the sunny weather shots we had already made).

- It is decided to "cover off" a scene (shoot the same subject from several angles) when there is no instruction to do so in the shot list. This will usually be done to give the editor more choices and especially to keep a scene interesting when it has become apparent that the action is taking longer than was originally thought.

All in all, the production stage is just following instructions as to what to shoot and (to a certain extent) how to shoot what is in the script/shot list. While a time contingency is always built in to the shooting schedule to allow for gathering extra footage and to cover unforeseen slow-downs, a good plan (script, shot list, and shooting schedule) will ensure an efficient and cost-effective shooting day.

Post-production

This is often considered the most important stage in the creation of a film or video project. It is the stage where it all comes together and you get to see your baby come to life. You get to see whether it says what you want it to say, whether it all works, whether you think the audience will love it, or whether you have next Thanksgiving dinner on your hands (that's called a TURKEY)!

Here are the most common post-production tasks:

1. Screen and log all of your footage.

2. Transfer useable footage to your post-production hard drive(s).

3. Acquire music and sound effects (sfx) and record any voice-over narrations or extra dialogue needed.

4. Shoot/capture video stills that may be needed (e.g., for graphic backgrounds).

5. Edit your picture and sound(s) together, using the script as a guideline and making amendments and creative adjustments where you feel you should. It's a creative process that is the heart of the post-production stage.

6. Add transitions (like dissolves, wipes, and digital moves) between shots.

7. Add graphics and animations where needed.

8. Preview session(s) with the director or client.

9. Make copies for distribution.

Okay, that's a lot. Let's step back to the beginning of that list and further define some of these tasks:

- **Screening and logging** Screening and logging is the process of watching your footage to choose the right takes to capture. This can be done with a playback deck or camera attached to a monitor, or while you are transferring to your hard drive. In any event, you should have a monitor attached to the output of your camera, as the process of capturing footage to your computer's hard drive is only displayed in a small window on your computer screen, can often make your footage appear jerky, and will sometimes not allow you to hear sound during the capture, all because of the processing speed of your computer. A monitor attached to the camera will provide a clear, larger display, along with sound. Figure 6-1 displays a written log for tracking this.

FIGURE 6-1 A written log for tracking screening and logging

Roll	Scene	Shot	Timecode In	Timecode Out	Description	G/NG
1	12	3	13:22:04	14:10:06	LS – Doug enters building	X
	12	3	14:23:13	15:12:07	" " " "	OK
	12	6	17:20:01	17:28:25	CU – Doug at desk	OK
	13	2	18:12:09	18:28:13	MS – Marilyn smiles	X
	13	2	19:10:17	20:01:15	" " "	OK
2	22	8	1:02:02	1:47:26	Good bridge shot	OK
	24	xtra	1:55:12	2:37:18	CU – Clock on wall – 3PM	X
	24	xtra	2:37:27	2:55:19	" " " " "	OK

FIGURE 6-2 An analog-to-digital bridge

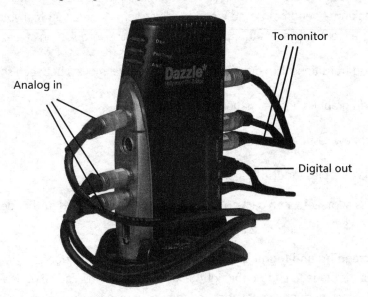

Analog in

To monitor

Digital out

- **Capturing** This is the process of electronically transferring the camera footage to your computer hard drive. It is referred to as "capturing" or "digitizing" the footage. While you can capture analog information (like footage from an old VHS tape) using an interface device known as a bridge (Figure 6-2), you will capture most of your footage directly from your digital camera (or playback deck) using only a FireWire or USB cable (see Figure 6-3).

FIGURE 6-3 A FireWire connection to a camera

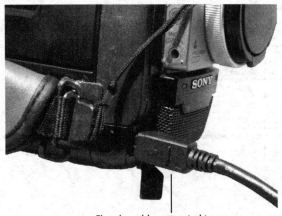

Firewire cable connected to camera

Follow your log and don't capture everything you've shot! There's no point in capturing the shots that are marked as "No Good" on your log. You'll never use them, and it's just a waste of time and drive space. I'll cover the technical aspects of capturing in "The Basics of Editing" section in Chapter 9.

- **Music, sound effects, and voice-overs** The gathering and/or recording of music, sound effects, and voice-overs is usually done during the post-production stage.

Music

As we go into more details about post-production, let's first talk about music. Most productions would suffer enormously if they didn't include a music track. Music can be used under the program's title and opening credits, under the closing credits, and as an underscore to the body of the program. Music sets a mood for the story line and a tempo for the visuals.

So, where do you get music from? Not from your CD collection—unless you retain a copyright lawyer who will contact the publishing company with what might be a very expensive and long, drawn-out negotiating session. There are at least three different copyrights you will have to gain rights to for any piece of commercial music: composer's rights, performer's rights, and synchronization rights.

Generally, if the composer has been dead for more than 50 years, the music enters the public domain (no more composer's copyright). Because Johann Sebastian Bach has been dead more than 50 years, you may use his music without paying for the composer's rights. However, if the performance you have chosen of his music was played by, say, the London Philharmonic Orchestra, then you will still have to pay the publisher performance rights so that the musicians get their fair share. You will also have to pay synchronization rights, which is the right to transfer the music from the CD onto your computer hard drive for editing and eventually onto every copy of the finished program that you make.

If you just must use a specific piece of music, you will have to jump through these hoops and pay the price. *Do not* try to get away without paying copyright charges. The legal ramifications are serious! Even if your program is a "not for profit" film festival entry, you must investigate the copyright. Sometimes a publisher will grant you the rights for free (or very little cost) for festival films, but not always.

Where else can you get music (maybe even cheaper)?

- Hire John Williams to compose, score, and record your music with a full symphony orchestra in a Hollywood recording studio.

Okay. Let's get serious.

- Purchase music from a production music library. These libraries can now be found online (e.g., www.killertracks.com) and are reasonable to purchase. Most music in these libraries consists of title and underscoring music in a variety of genres, tempos, and orchestrations. It's often sold by the minute—sometimes by the tune—and there may be a scale of price, depending on how many copies you are distributing and whether it's for broadcast or DVD only.

 The only drawbacks to library music (which is composed, scored, and recorded specifically as production music) is that you might not find exactly what you're looking for, and you certainly won't find any popular, current hit music. Also, any other bozo who puts up the cash can use the same tracks that you've bought for your production.

- Hire a composer/musician to create music for you. Anyone with a good midi-controlled music setup, a computer for recording and mixing, and a bag of talent and playing skills can knock off a good music sound track for you. How much you will spend will depend on the amount of music you need, its complexity, and the rates the musician charges. With a good midi setup and recording/multitracking capabilities (you gotta love computers—they make this part so easy and inexpensive), one musician can sound like an entire symphony orchestra if necessary. This may not be as cheap as buying from a music library, but you get what you want and no one else can use the same music.

- Utilize the technological advantages of a music generation program. These fabulous programs allow anyone to compose and record high-quality, multitrack music on their computer. Did I say anyone? Well, you should have somewhat of a musical ear, but musical knowledge and the ability to play an instrument are not required.

These programs use musical loops that are created in studios by professional musicians and that you place on a timeline in the software. Each loop may represent an individual instrument playing a few bars of a beat or musical riff. The loops can be allowed to play as long as needed in your composition, the key can be changed when necessary, and special effects (like reverb, equalization, fades, and phase-shifting) can be added easily.

Once you've built up enough tracks (drums, rhythm guitar, piano, bass, etc.) you can output a finished mix in the file format that your editing software likes best (.aiff, .wav, etc.). Your creation is copyright free, so you can use it anywhere.

I have successfully used Soundtrack Pro and Garage Band on my Macs. For a PC you might investigate Sony Acid Music Studio (light and pro versions) and Cakewalk Music Creator.

- How are you at strumming a guitar while you play the kazoo? With Mom on the musical saw and Dad playing the spoons, you might have a killer sound track! Right? Forget it!

A quick tip here: When you're looking for *background* music (music that is secondary to other, feature sound) you should usually choose instrumental music. Lyrics might compete unfavorably with the important sounds. Vocals can be used, however, when the lyrics compliment your story line.

Sound Effects

Sound effects are used in a program to provide the sound of things that cannot be recorded while you are shooting your live footage (rattling machine guns and grenades exploding when your actors are actually toting toy guns and tossing hollow plastic Easter eggs) or just to enhance the ambience of the sound track (the forest scene is deathly quiet because the birds clammed up as soon as the camera rolled, so we throw in a chirping birds effect). We also use carefully staged and synchronized custom-made effects to enhance a character's footsteps or the sound of a punch in the face. These are called foley effects, after Jack Foley, a pioneering sound effect editor at Universal Studios in the 1930s.

Standard, royalty-free sound effects can be bought at any large music store. Most of these effects, however, are old (occasionally you can hear the crackling of the vinyl record they were originally recorded on) and not very good. But, sometimes you

can use them to good advantage. Then there are the sound effects found at the aforementioned music library sites. They are costlier, but you usually get top-grade sounds—and hundreds of them. Unlike music, they are usually sold on a one-time buy-out. Once you buy the package, you can use them forever. If you search the Internet you will likely find hundreds of sites with low-cost or even free sound effects.

The last way to acquire sound effects is to make your own. Here's a recipe for a custom sound scape I had to produce several years ago. The scene was to represent Captain Vancouver's visit to what is now Victoria Harbor in 1792. The sound effect of the boat at anchor near the shore was created as follows:

1. One pre-recorded commercial sound effect of small waves gently lapping a shoreline, which doubled for waves gently lapping at the side of the ship.

2. One homemade sound effect of the ship's masts creaking as the ship rocked gently on the waves, made possible by holding a microphone to the hinges of a squeaky door and slowly swinging the door back and forth.

3. Several short rings of the ship's bell (I actually did have a small bell lying around that I used).

4. Another commercial sound effect of roaring waves, crashing on a distant beach, which was run at very low volume in the background.

5. And last, a smidgeon of pigeon. Actually, some canned seagull screeches.

6. Mix well and when the soundscape ends, repeat as necessary (I think we ran it at least three times under the narrator, but no one would ever realize this).

Voice-over Narrations and ADR

Often, the sounds you record while shooting your visuals will not suffice to tell your story. Extra voice recordings of a narrator may need to be added, especially for documentaries and training or promotional videos, or, if your actor's dialogue track is faulty or of poor quality, some dialogue may have to be replaced, called automatic dialogue replacement (ADR).

Voice-over narrators make their living (or a part of their living) by honing and practicing the techniques of using their voice as an instrument to command an audience's attention. They are truly actors, as they often will assume a specific characterization in their voice as they read the script. In any large city you can find hundreds of narrators, both male and female, from any age range and many types of voices. The cost may vary significantly, depending on the individual's base rate, time in the studio, length of the script, and whether or not they are represented by a talent agency (many are independent).

There are two main ways to choose your voice artist. The first way is to listen to several demo reels. This way, you get an idea of the different types of voice work they can do (serious, light, comedy, character voices, etc.). The second, and perhaps the best way to choose, is by holding auditions using parts of your script and coaching each voice artist in how you would like the script to sound.

If you are recording in a home-based studio, you will want to ensure a quiet environment with enough sound-absorbing material in the recording area (couches, curtains, etc.) to defeat potential echoes, and use a very good microphone. Also, while I have never cared about using headphones while recording the hundreds of voice-overs I have done over the years, most voice artists will want a good set of headphones so they can hear their voice while they are recording.

Acquiring Stills

Still pictures for your video production can be obtained by accessing a digital picture, scanning a physical photograph into digital form, or grabbing a freeze-frame from your video. When acquiring stills from an outside source, always be aware that they may be copyrighted by the photographer or picture bank. *Don't use them* unless you know for sure and have either been granted a license to use them or you're sure they are in the public domain (no copyright). If you shot the stills yourself or are lifting a freeze-frame from a video that you shot, there is no problem.

A few technical notes:

- Try to use mostly horizontal shots, as verticals will have to allow for large black borders on the left and right sides if the whole image is to be seen.

- The higher the resolution the better. No less than 640 pixels by 480 pixels.

- If you have grabbed a still from moving video, you may have to de-interlace it with a de-interlacing tool within your video editing software. Otherwise, you will be viewing two stills of the moving subject, the odd field and the even field, and this can make a very messy picture. De-interlacing software will get rid of one field and look much sharper.

Editing

This is the true heart of the post-production process. It's where you cut each shot to length and assemble them in the proper order, add the sound tracks and other elements, and finesse the program into its finished form. Editing is a complex combination of technology, logic, and art. I'll tell you much more about editing in Chapter 9.

Transitions and Effects

Many editors leave the inclusion of transitions and effects until the program editing is almost finished (ah, the beauty of nonlinear editing). Personally, I like to see as much of a finished product as I can as I work my way through the edit. Suit yourself on this.

Transitional Effects

Transitions, of course, are those effects that "transish" (I know, it's not a real word) from one shot to another. Technically, a straight cut is a transition, but the most commonly used actual transitional effect is the dissolve (one shot fades out exactly as another shot fades in, causing a blending of the two shots). There are hundreds, if not thousands, of other transitional effects you can use, but you must be careful not to make your poignant love story look like a sci-fi extravaganza by using one fancy effect after another.

Here are a few guidelines about using transitional effects:

- A simple cut is most often used only between shots within the same sequence.
- A dissolve is primarily used to denote a passage of time, a change in location, or as a transition between sequences (see Figure 6-4). A momentary dip to black and back up to the next shot is also used in this way.
- Occasionally, you may wish to use a digital effect such as a page turn (Figure 6-5) or a rotating flip from one shot to another, but leave most of the fancy fly-ins, squeezes, shutter wipes, etc., for training videos. They need the spicy effects to keep the audience awake.

FIGURE 6-4 Halfway through a dissolve

FIGURE 6-5 The page-turn effect

Special Effects

Special effects in editing are the magic tricks: things like a picture-in-picture composite (see Figure 6-6); making a full-frame shot shrink down in size, spin around, and move across the screen; compositing two shots together to make one shot, and putting an actor, shot in front of a blue or green screen, into a virtual set.

There are thousands of standard special effects, and with the sophisticated software available, the number of effects is really limitless. Whatever you can imagine can be put on the screen—if you have the budget, the time, and the skills. Some interesting software that is used specifically for special effects will be listed in Chapter 10.

Graphics and Animations

I'm bundling these two together here. They are similar in function, but really, there are some significant differences. First, let's consider graphics.

Graphics

Graphics are those images that provide information not given by the live shots. This includes text graphics in the form of the program title, credits, subtitles, lower thirds (identifying a person or location that is visible on the screen by superimposing

FIGURE 6-6 A special effect shot: a live action picture-in-picture with drop shadow

identifying text on the lower portion of the screen), etc., and graphic images such as maps, logos, pictorial or graphic arts backgrounds for text, etc. Figures 6-7 through 6-10 give examples of various kinds of graphics.

Someone has to make these graphic images and then save them in a resolution, size, and format that will be acceptable to your editing software. Often, the editor is also the graphic designer.

FIGURE 6-7 A simple program title

FIGURE 6-8 Text over a live image

FIGURE 6-9 An animated line on a map

FIGURE 6-10 A corporate logo

This book is not intended to include a course on graphic design or execution, so if your eye for composition, color, and graphic structure isn't up to the task, you might want to consider farming that part of your project out to a professional graphic artist. However, most editors are at least capable of creating reasonably good title and credit sequences. Your editing software will likely (and really should) include a pretty good (if not dazzling) character generator for titling. All I can say is, read your manual to become competent in its use and keep the text within the "safe area" boundaries that your editing software will (likely) be able to show you. Figure 6-11 shows an example of text within the "safe area," and Figure 6-12 shows what not to do.

FIGURE 6-11 Good title composition. The inner superimposed line tells you where the safe title area is. The outer line denotes the safe area for the entire picture.

FIGURE 6-12 Poor composition. The line of type is too large.

Animation

Animations can be anything that must be put into motion on the screen that would not ordinarily move. It can be as simple as moving a static image from one part of the screen to another or as complex as depicting a T-Rex running amok through your neighborhood. This is achieved by creating movement artificially for each frame.

In the early days of animation, this was done by hand, manually. A very long, annoyingly delicate, and dreadfully boring process. And, therefore, ridiculously expensive. Once again, we have to be ever so thankful for the computer, the wonder of the modern age (all bow down!). The computer has made the animation process so much easier and the results so much better. While we still revere animation artists like Willis O'Brien (the animator of the original *King Kong* movie in 1933) and Ray Harryhausen (*Mighty Joe Young*, the original *Clash of the Titans*, etc.), ya gotta admit that *Jurassic Park*, *Beowulf*, and Peter Jackson's 2005 version of *King Kong* blew them out of the water technically. It's to be expected that animation should look better after so many years, but it's really the computer that allowed the tremendous realism and smooth motion.

Whew! Glad I got that off my chest.

These days, even a hobbyist with a moderately priced computer and some inexpensive software can, with perseverance, produce some impressive animation. Flying text titles around the screen is easy and usually can be accomplished within your editing software itself, although separate animation programs will be required for character animation or motion backgrounds.

Research what's out there and determine what you need or could get good use of. The learning curve for some of this software can sometimes be daunting, but the results can really make your production shine. Again, I'll be including some of my favorite animation software titles in a special section near the end of this book.

Preview Screening(s)

The reason that I put the bracketed "s" at the end of the heading is that there will rarely be only one screening of the "finished" edit. The director will likely want to make some revisions—perhaps several—and unless the editor and the director are the same person, several screenings may need to be played to get a feel for the pacing

FIGURE 6-13 This fine fellow resides in my editing suite.

of the program. The same goes for showing the program to a client, producer, or investor(s), especially if these people are putting up the money to create this epic.

If you aspire to be an editor, you must possess a temperament that allows you to see the same program and listen to the same music tracks over and over and over again, to the point where most people would go stark raving mad. Actually, most editors don't mind this. It could be said that it's because they're already starkers (see Figure 6-13).

Duplication and Packaging

Okay, at this point, you might be out of the loop. But, if you're an independent producer or corporate video producer, you might very well be responsible for this important last stage.

DVDs

If you intend to distribute on DVD or Blu-ray, you might want to know that there is a difference between DVDs that we can burn ourselves on our home computers and the movies that you rent or buy at the video store. The latter are glass-mastered and then pressed from this master, much like vinyl records were. Burning a disk is called "duplication" and is the process of copying the information from the master disk and burning it onto successive disks. It has approximately 95 percent compatibility across DVD players. "Replication" requires a glass master to be made, which may well be produced from a Betacam master; it has 100 percent compatibility across DVD players and requires the information to be stamped onto blank disks as they are manufactured. Most companies that produce quantity copies of DVDs require the glass-mastering process for over 500 copies.

And what about packaging? Well, if you are responsible for the look of the packaging, you should be conversant with page layout programs, graphics programs (as mentioned earlier, you may want to farm this out), and perhaps own a program that is made specifically for package design and DVD labeling. DVD boxes and cases can be purchased in quantity from companies specializing in providing the film and video industry with disks, tapes, boxes, labels, and duplicating machinery.

The Web

This is a tough one! The mysteries of compressing your video and converting it to the proper format for web distribution are as arcane and complex as a full-on magical spell from a Harry Potter movie. Here's the skinny as I understand it (which isn't much): When shooting your original footage for the Web, it's a good idea to mount your camera on a tripod for stability and keep unnecessary movement to a minimum. The reason for this is that the compression software that will be used to prepare your video for web streaming captures the first frame, and when the second frame comes along it only captures those parts of the picture that have changed. Therefore, if you have a person moving in front of a stable background of, say, buildings, the only changes made in that frame are the moving parts of the person. This is how your video can be compressed down to a reasonable size. This compression scheme continues until the next keyframe (perhaps every 24 frames), when the whole process starts again by capturing an entire frame.

Next, there's the question of what format to convert your video to. By this I mean should you use QuickTime, Windows Media, Flash, or Real Player? Flash is the big winner here, as a Flash video file can be played on both PCs and Macs with a free, downloadable plug-in for your browser, and it creates a very small file size of your original video without sacrificing as much quality as the other contenders. Windows Media is probably the next most popular format, although Microsoft no longer has player support for the Mac (second-party plug-ins are still available). QuickTime is certainly a contender because of its ease of control during playback and the large number of codecs it is compatible with. While it was originally a Mac product, it is now used extensively on PCs as well. The browser plug-in and stand-alone player are both free. Real Player isn't a player in this game. It's not well supported.

You might have wondered about the word "codecs." (Or has this stimulating section anesthetized your brain?) The word "codec" is short for "coder-decoder" or "compressor-decompressor." A codec compresses data for streaming on the Web and decompresses it for viewing on your computer. Dozens of codecs can be used. Some are good at compressing motion (but maybe sacrificing color precision or picture quality), while others might excel at keeping colors true or quality high.

There are many software products out there that will help you through the mazes of compression for the Web. On my Mac I use a program called Compressor (very creative name), which was a part of the original Final Cut Pro editing suite of programs. I also get good service (and less hair pulling) from a program called DV Kitchen, which is easier to understand and enables you to tweak various parameters to create the perfect "recipe" for your compression. (Get it? *"Recipes"* in DV *"Kitchen"*? Get it?)

Oh, I could blather on for pages yet. But you'll be happy to know that my brain is beginning to melt and I really can't tell you much more about this subject. The Web has a wealth of confusing information on this subject should you wish to go on a real nerd-rampage. Suffice it to say that there are many programs that can help you (almost painlessly) through this process.

7

Pre-production—The Planning Stage

Many beginning filmmakers skimp on the planning process. Proper planning can make the difference between a smooth shoot, a happy editor, and a director that smiles a lot—and a finished project that does not live up to expectations.

Pre-production Planning

The pre-production planning stage is like creating a blueprint for the construction of a house. Without a well thought-out plan, the building will likely fall apart during construction. Let's build a solid project.

The Planning Paperwork

Besides drawing up contracts, preparing release forms, and deciding where the Porta-Potties will be placed at the outdoor locations, there are a few important pieces of planning paperwork that must be created before shooting can commence. Specifically, I am referring to the proposal, the script, the shot list (also called the scene list), and the shooting schedule. You must have most or all of these documents in order to effectively and efficiently create a program (at least one with more than five shots). While I've listed them here in a common order of their creation, it isn't unusual at all to have the script come first, before the proposal.

Definitions and Uses of the Various Documents

For those who hate paperwork (most of us creative types), this section defines the most important documents to consider during the planning process. You may not need all of these planning tools for a given production, but some (like the script) are absolutely necessary.

The Proposal

A proposal is a document that proposes a business agreement between a producer and an investor. It is a pitch for funding, and as such it must contain enough information about the proposed project to convince the potential investor to put up some cash, while not containing so much information that the investor will tire of the read, put it down, and walk away. So, it's an outline. A condensed version of what you propose to produce. It contains these elements:

- **A working title** This title doesn't have to be the one that the program is finally released under. Its use right now is to allow the reader to distinguish it from other proposed projects that they may be considering.

- **A mention of the medium (not the type that channels spirits)** The medium is what the program will ultimately be released on (Mini DV Tape to DVD, Betacam, 16mm film, 35mm film, etc.). It is doubtful that anyone will finance you to the tune of a million dollars or more for a Mini DV production, but they might cough up some major moola for a 35mm film production that could play in large movie theaters.

- **A rationale** Why is it important to make this program? What rationale can you cite to convince the reader of the validity and even the necessity of this project?

- **A scenario or synopsis** This is really an outline of the story line. You do not provide a full script in the proposal. Most investors would not take the time to read through it. If they express interest, you can supply a script to them later. Likely your proposed budget will include script development, so you might not even have a script at this point. The scenario should also include mention of the treatment you will use in creating your script (see below).

There are more elements to the proposal, but I want to explain the different treatments you might use to develop a production. There are four main ones:

- **The documentary treatment** Documentaries report real events. This is often the most difficult treatment to outline, as much of it may be unscripted. A documentary on wildlife may be totally unscripted until shooting is done and a story comes out of the footage. A documentary on the life of Alexander Graham Bell, inventor of the telephone, would likely be tightly scripted before the cameras roll.

 Examples of a range of documentaries, from homemade videos to those intended for larger, more diverse audiences, include:

 - **Family and social events** Holidays, weddings, parties, etc.

 - **Meetings, seminars, lectures, etc.** A documentation of this type is actually a true documentary (as much of a yawner as it may be).

- **Evidence shot for legal proceedings** Where a re-enactment is staged or various angles of a location are shot that are important to the proceedings.
- **Scripted informational programs** Wildlife documentaries, historical programs, and reality programs that are a depiction of actual events, situations, and ideas that are socially relevant.

- **The commercial treatment** This production attempts to persuade the audience to like, dislike, or feel the need for something.

Examples of commercials include

- **Community events calendars** What's hot in local events and entertainment.
- **Political ads** "Buy my ideas," "vote for me," "don't vote for him or her."
- **Public service announcements** "Say no to drugs," "help the needy," "hug a tree," "send me money just because I deserve it" (unfortunately, some people fall for this one!).
- **Product commercials** "Buy my soap," "buy this car," etc. These are the types of commercial we're most accustomed to—we are inundated with them!

- **The dramatic treatment** Any mock situation that simulates reality. Productions in this category include
 - **Comedy or dramatic shorts** Usually less than 30 minutes. These are often used as entries into film festivals or as time fillers on TV. Be aware that even if a production is a comedy, it is still considered a dramatic treatment because it is a piece of fiction.
 - **Situation comedies** Written in dramatic style (fictional) but designed to be humorous.
 - **TV or motion picture dramas** Musicals, serious dramatic pieces, horror, science fiction...whatever is woven from fiction.

- **The educational treatment** This product attempts to train or teach and is designed strictly for informational purposes. Educational programs include

 - **Employee training** Job skills, safety training, customer service skills, etc.

 - **Lectures/demonstrations** Similar to one of the documentary types, but heavily reliant on demonstrations being recorded along with the lecture. An example might be a lecture on medicine with a live patient used for the demonstration part.

 - **Academic programs** Math, physics, astronomy, social studies, history, etc.

 - **How-to videos** My personal favorite. I've produced a few and laughed my way through a few others. Examples are cooking videos and those that promise to improve your golf swing. Other titles promise to teach you how to make millions on the Internet or train you how to lost 40 pounds in 20 minutes. Riiiiight!

I should mention here that you can mix two treatments together. As an example, I'm sure you've heard the term "docudrama." That's a mixture of the documentary and the dramatic treatments. If we were really producing a documentary on the life of Alexander Graham Bell, we could dress up some actors in costumes of the period, give them some lines to speak (which may never have actually been spoken but help to tell a historical story), build a set based on what we know of Alex Bell's laboratory, and shoot a dramatic segment or two. Or perhaps the whole documentary might be shot in the dramatic style.

Having said that it is okay to mix a couple of treatments, I caution you against utilizing too many treatments in your program. A docudramatic-educational commercial would become so confusing that your audience would not know what message(s) you were trying to convey. Much head scratching would ensue.

Back to the Proposal

Okay, now that you understand what treatments might be included in your proposal, let's pick up where we left off. Next come the technical aspects. Anyone reading your proposal will assume that you need to have a camera, a tripod, some lights, etc. But

what they will need to know about the technical aspects of your production are those uncommon, special requirements that will significantly affect the budget.

For instance, if you are doing a documentary on how the railway passenger coach affected the settlement of the western parts of North America, you might have to send a team of researchers to various museums and archives to study and acquire photographs and old films. You might also have to hire the services of a production house that specializes in building complex and realistic models (either physical or digital) of some of the old trains and coaches that no longer exist, and animate some elaborate, scenic sequences featuring these models. That will likely be quite expensive. It's not something you'd do in every project you produce.

So really, any outstanding technical consideration that will have a significant impact on the budget should be included.

And last (insert fanfare here), the budget. For investors, this is the real meat of the proposal. They want to know not only how much you need, but they want it broken down so that they can see you'd be allocating and spending their money wisely.

You might think that the average investor knows nothing about movie making and would not be able to tell whether your allocation of funding is accurate. WRONG! If you're advancing large amounts of your money to have someone else create a project on which you hope to make a profit, you will usually do your homework. Besides, it would be fairly obvious to anyone that allocating two million dollars for special effects for a courtroom drama would be very questionable.

The boxed text on the next three pages is a fictitious example of a simple proposal. This is a completely fictitious proposal, and the dollar amounts might not be totally accurate, but it contains all of the elements required for investors to understand your project and its financial necessities.

A proposal can also be used to educate anyone else as to what your project is about. If you are handing this out to your crew to bring them up to speed on just what they are working on, or to producers or other industry people to show what you're currently working on (as a shameless self-promotion), or to your family and friends to impress them with what a movie mogul you are, you might want to take out the budget part.

A Proposal for the Production Of

On the Right Track

A two-hour high-definition television program

Medium:

Betacam HD Video (production and distribution)

Rationale:

The history of how our forefathers created our living environment, why they came to our current home, and how they got here is a tense and exciting story that credits the human spirit and our determination and creativity in dealing with seemingly insurmountable hardships and danger.

By choosing a single form of transportation, we are able to tell stories of vast westward migration during the 1800s with the ever-popular theme of rail travel. It's really about utilizing technology to conquer the elements, the landscapes, and the dangers inherent in such a trip.

Scenario:

This two-hour television program will tell the story of the importance of the passenger car in North America's rail history as it was used to transport settlers across the rugged terrains of plains, deserts, and mountains during the 1800s to settle in and grow the western half of our continent.

Several classic trains will be highlighted, with a focus on the different styles of passenger cars.

Special emphasis will be made about the hardships endured, as well as the comforts and efficiency of this form of travel compared to wagon trains and river routes.

While much of the program will use a voice-over narrator, dramatic re-enactments will also be interspersed with actual historic photographs, film clips, and interviews with today's prominent historians and railway personnel.

The treatment of this program is primarily documentary, but because it will also include several sequences of a dramatic style, it qualifies as a docu-drama.

Technical Considerations:

As this program will be relating historical facts for which very little visual material exists, we will need to contact most major museums, archives, and rail companies to acquire photos and (where possible) film clips of some of these old trains and their cars.

As a major component of this program will be to stage several sequences showing these trains in action, including some famous train wrecks, we will have to engage the services of a digital animation house with the facilities and skill to make these scenes both exciting and realistic.

The regular equipment base for the live-action shooting will also include a motion-control rig for tracking the live actors within the digital train car windows during digital moves.

Budget:

The total budget for this program is calculated at $343,035.00. This breaks down as follows:

Initial Research:

Five professional researchers for 60 days at $300/day = $90,000.00

Phone, fax, etc., communication is estimated to run $1,700.00

Script Development:

Researching and finding prominent historians, rail personnel, and others to be interviewed on camera: 4 weeks (20 days) × $300/day = $6,000.00

Scriptwriting from supplied initial research: 8 weeks (40 days) × $350/day = $14,000.00

Pre-production Planning:

Including equipment booking, contacting and hiring crew, researching locations, booking studio space and locations, script breakdown, creation of shooting schedule, drawing up of contracts and release forms:

Labor: 3 people × 60 at $300/day = $54,000.00

Legal fees (drawing up contracts) = $7,000.00

Office expenses (supplies, services, etc.) = $12,000.00

Production:

Interviews, location shots, and on-board train shots: 20 days with a 8-person crew (director, DOP, sound, grip/electrics, lighting grips (2), production assistant, makeup): $2400/day × 15 days = $36,000.00

Post-production:

Ninety days of editing at $600/day = $54,000.00

Color correction and sound mix = $6,000.00

Music clearance = $22,000.00

Copyright legal services = $12,000.00

Total = $326,700

Contingency for cost over-runs and unexpected expenses (5% or total) = $16,335.00

GRAND TOTAL = $343,035.00

The Script

Oh boy! Big subject. Writing technically acceptable movie scripts can be a challenging endeavor. There are dozens of formats you can use to write the script, but they are all derived from this simple definition:

> A written version of a play, film, or other dramatic production that is used in preparing for a performance.

Scripts can (and are) written in many different formats. As it is not the intention of this book to teach script writing, I suggest you surf the Web for information on this subject. Many script styles and types, including known movie scripts, are available on the Web. If you want to know how to develop, write, and format a movie or TV dramatic script, I suggest you try www.scriptologist.com.

For television and motion picture dramas, script formatting is very critical. Your labor of love will be rejected if you don't use the established conventions of the script-writing craft. If you are submitting a script for consideration, it is also a good idea to study the subscription regulations of the intended producer or production company and the legal ramifications of allowing your idea to be read by those who might reject your script but you fear could steal your idea. A good copyright lawyer would be able to safeguard you in this instance.

Another thing that could happen is that a producer purchases exclusive rights to your script, but shelves it for an indefinite period, thereby keeping you from the really big bucks and glory. KNOW THE RULES!

Figure 7-1 shows the type of script format that is often used for TV commercials. This example might seem silly, but you get the idea. In this form of script, we know which shot number is being explained (SHOT), who or what is in front of the camera (SUBJECT), how the camera should frame the shot (VISUALS), what sound will be used (SOUND), and how much time (TIME) the shot should take up in the finished program. This is not only a shooting script, but a full script that could be used by the editor to determine where the music cues and transitional effects come in.

The Shot List

The shot list is a breakdown of the script into its individual shots. Preparing this document is valuable, as it forces you to pre-visualize your program before shooting. This gives you a plan for shooting that has been carefully thought out as to how the shots will help tell the story and follow continuity while editing.

Even though you will likely set up camera angles and positions when you're actually on the set (called blocking), you will benefit by having a written plan that you can follow, amend, or even ignore if you find that the reality of the set offers better shooting ideas.

The shot list shown in Figure 7-2 is similar to the commercial script shown in Figure 7-1, but leaves out the sound notations and only includes minimal story details. It's best to mark your script with shot numbers as you read through it visualizing the scene. These shot numbers are transferred to the shot list as you create it so that you can easily refer back to the script to refresh yourself on the details of the story line.

FIGURE 7-1 The scripts for TV commercials often appear in this format.

	BIG AL'S WIDGETS AND WHAT-NOTS (30 second version)			
SHOT	**SUBJECT**	**VISUALS**	**SOUND**	**TIME**
1	Big Al standing in front of his store.	Long Shot showing store front	MUSIC UP & UNDER Al: "Hi, I'm Big Al from Big Al's Widgets & What-Nots."	3 seconds
2	Big Al	Cut to close-up	Al: "Have you ever wished you had just the right widget or What-Not for the job? Well, wish no more!"	5 seconds
3	Interior of store.	Wide, panning shot	Al: "At Big Al's we have over 5000 square feet of Widgets, What-Nots and junk that you can paw through."	6 seconds
4	Hand enters frame with classic Widget.	Close-up against defocussed shot of store interior	MUSIC OUT Narrator: "At Big Al's we care about the quality of the goods we sell."	4 seconds
5	Hand written guarantee.	Dissolve to close-up	Narrator: "That's why every sale is backed by our unconditional two hour guarantee."	4 seconds

Here's a narrative of the story line for the beginning of a short comedy. Shot numbers are included here.

(1.)Three men are standing at a bus stop. (2.)One man reaches into his jacket pocket for his handkerchief and, unbeknownst to him, his wallet falls out (3.)and lands on the ground at his feet.

FIGURE 7-2 The shot list helps you think of your script in visual terms.

	WALLET WARS Shot List		Page 1 of 10
SHOT	**VISUAL CONTENT**	**TECHNICAL CONTENT**	**TIME**
1	Three men standing at a bus stop.	Fade up from black L.S. Cut to . . .	5 sec
2	Talent #1 reaches into his pocket for a handkerchief . . . his wallet falls out.	M.S. Cut to . . .	4 sec
3	The wallet hits the ground.	C.U. - including feet. Cut to . . .	3 sec
4	Talent #2 sees this, quickly looks left and right, looks at camera and smiles.	Low angle M.S. Camera pans left and right to follow T2's eyes and then centers up. Cut to . . .	6 sec
5	T2 begins to casually stoop down as if to tie his shoe.	Level L.S. Cut to . . .	4 sec
6	T2 attempts to grab wallet, but T1 steps on the wallet.	C.U. on T2's face. Camera tilts down to follow T2's hand and follow to wallet Cut to . . .	5 sec
7	T2 stands up and looks at his watch.	Level L.S. showing all 3 men. Dissolve to . . .	4 sec
8	Line of people. 2 more people have joined the line.	L.S. (match of shot 7) Cut to . . .	5 sec

(4.)The man next to him, realizing that no one else is aware of the wallet, smiles in evil anticipation. (5.)Pretending he has to tie his shoe, the would-be thief kneels down. (6.)Unfortunately, the unaware owner steps on the wallet, making the snatch impossible.

(7.)The would-be thief stands up and pretends to look at his watch as if nothing has happened.

(8.)Much later, they are still waiting for the bus and several others have joined the line.

A few points about this simple shot list example:

- As the characters are not given any names, they are referred to as T1 (Talent 1), T2, etc.

- Notice that the visual content information is a shortened version of the full script.

- In the technical content column, we use abbreviations for long shot (L.S.), close-up (C.U.), etc., which are explained in the next section.

- All camera moves are noted here.

- Shot transitions (cut to… and dissolve to…) may or may not be noted here.

The Simple Sequence

When you are designing your shots, you might want to keep this formula in mind for structuring them. It's called the simple sequence and it works like this:

1. First, start with a wide shot that shows the audience the setting. This is called an establishing shot because it establishes the setting and characters. In our example in the previous section we use a long shot.

2. Next, tell your story with any types of shot distances that seem right to you.

3. Along the way you could add either a cut-in or a cut-away:

- A cut-in is a close-up of a detail in the scene that might be hard to see unless a close-up is used (e.g., the wallet landing on the ground).

- A cut-away is when you cut away from the main action to a different but related action. It is usually in a different location than the main action. While we don't have one in the example shot list, let's say that at a certain time in the program we cut away to the bus driver in the bus, stopped on the side of the road miles from our main setting, pouring coffee from a Thermos. He's on his coffee break.

4. A re-establishing shot (again, it should be a wide shot to encompass most or all of the set) is meant to refresh the audience on how the set looks and perhaps show what changes have happened to the characters and the setting (shots 7 and 8 of the example shot list).

Of course, not all scenes start with a long shot and use all of these other shot types, but many do. Use this formula when and if you feel that it will serve the audience's understanding of your plot line.

Master Scene Shooting

There is a particular style of shooting a sequence of shots that is often employed to capture dialog scenes and any other sequences where the action can be repeated easily over and over. This is called master scene shooting. Shooting in this manner makes it easier for the editor to be creative, as it provides the entire sequence from several camera angles.

Here's how master scene shooting works: Let's say you are going to shoot a dialog sequence between two characters. First, stage your actors in the setting (Figure 7-3). Next, as the director, you get to draw an imaginary line that cuts right through the actors (good thing it's imaginary), as shown in Figure 7-4.

Now, you choose a side of the line that you will shoot all of your shots from for this sequence. The 180° rule states that you must make all of your shots from this side of the line—not necessarily on the curved line, but always on that side of the line—as shown in Figure 7-5.

FIGURE 7-3 The two actors are staged.

FIGURE 7-4 This line is called the action axis.

Action axis

FIGURE 7-5 The 180° rule

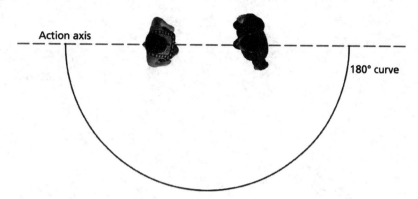

While you don't have to shoot your master shot first, it is quite common. In the example shown in Figure 7-6, our two-person conversation will be a 2 shot and will include the entire dialog sequence.

In shot #2 you again capture the entire sequence (Figure 7-7). In this close-up you will shoot a single character speaking his or her lines and also the time that he or she is

FIGURE 7-6 The first (master) shot

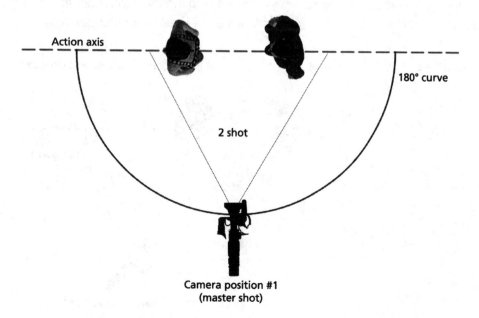

FIGURE 7-7 Shot #2 can be a single shot of either character.

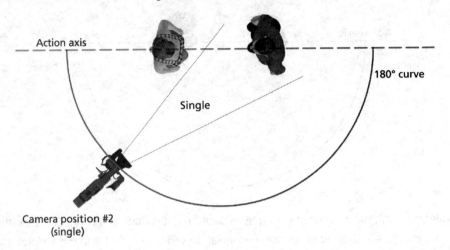

just listening to the other speaker. This can be used for reaction shots by the editor if the facial expressions are worthwhile. Repeat the same process for shot #3, but for the other speaker (Figure 7–8).

Each of these shots includes the entire dialog scene, so the editor can edit this sequence in several ways while always being able to use the master shot to cut back to and re-establish the setting and characters or for breaking up the close-ups.

FIGURE 7-8 Shot #3 is the same as shot #2, and the field of view (in this case, a close-up) should be matched.

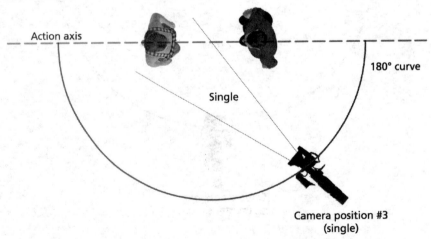

FIGURE 7-9 The big "X" means DON'T DO IT!

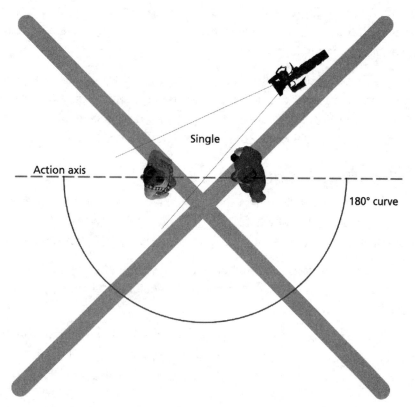

But wait! Why the 180° rule? Why can't we shoot from the other side of the line? Well, let's say that at a certain time in this dialog we crossed the line.

If you think this through from the point of view of the camera positions in shots #1 and #2, you will realize that this character will appear to be facing the wrong direction in this close-up. Because we have crossed the line, when the editor cuts to this camera, the character will appear to be facing screen left instead of screen right, as depicted in shot #1 (Figure 7-9). This will be confusing to the audience and is considered to be an extreme loss of continuity.

If you want to cross the line, you can do so by staging a slow, deliberate dolly shot during the time that the character on camera is speaking. The audience will see

the change in perspective happen before their eyes. They will see the character change from facing right to facing left as the camera rotates around the arc to the other side of the axis. This is acceptable, even though getting your camera dolly to execute a smooth arc can be challenging.

Master scene shooting can help the editing process by providing oodles of footage from which to create an excellent version (or several versions) of the scene, and remembering the action axis whenever several shots from different positions are to be tied together into a sequence can avoid audience confusion.

The Shooting Schedule

The shooting schedule is a document that allows people working on your production to know what is being shot at what location on a given date, which crew members are involved, and what equipment will be available. Figure 7-10 provides an example.

This makes it easier to track people and equipment so that nothing is unaccounted for and so that you do not have people and pieces of equipment showing up that are unnecessary.

First and foremost, it's a schedule. Therefore, it will give the times that have been estimated for shooting each scene. A scene may contain several shots, which might mean several set-ups. By estimating the time for each scene, we can ensure a smooth shooting day with less likelihood of failing to record the daily quota of shots. Often, the required crew will not be listed on the shooting schedule. Instead, a separate call sheet will be drawn up for personnel, including characters (actors) required for the day.

A Final Thought

Now that you've seen the up-front, pre-production work that must go into a professional production, you should begin to realize the importance of good planning. It will help you to pre-visualize your project, determine where the potential problems will be, and solve them before you begin shooting. You should create as many documents that help you to do this as you feel you need.

FIGURE 7-10 Sticking to the shooting schedule can help keep your production on track.

Day / Date Time	Scene	Int / Ext Day/	Shot Descriptions / Summary	Location	Characters	Art Dept. / Equip. Special Req.
THE CLAW **Shooting Schedule**						
Shoot Day #1 - June, 2012 - REQUIRED CREW - Cam., Snd., AD, Makeup, Grips, Gaffer, PA						
8:00 - 8:30 Am - Crew breakfast on location						
09:00 10:00	7	Ext. Day/Night	A hideous claw reaches up from the water. Marty runs.	Swamp	Marty	Mechanical Claw Fog Machine
10:00 11:15	9	Ext. Day/Night	Marty & the sheriff return to swamp.	Swamp	Marty / Sheriff	Fog Machine Cam. Dolly
11:15 12:00	11	Ext. / Day	Marilyn and Jake in the woods. Jake snatched by the monster.	Woods	Marilyn / Jake	Stedicam
LUNCH - Set up near swamp set behind trailers						
13:00 14:30	3	Int. / Day	Swamper in his cabin - looking out the window as Marilyn comes to the door.	Cabin	Marilyn / Swamper	Small Lowell Light Kit / Swamper's knife
14:30 16:00	2, 5, & 8	Ext. / Day	Swamper doing work at the cabin. Chopping wood, going into barn, sharpening knife.	Cabin Yard	Swamper	Cam. Dolly Swamper's Knife Axe

8

Production

This is the part you've all been waiting for. Lights, cameras, action, and a heck of a lot of work in a short period of time!

Shooting Your Video

Besides knowing how to use your camera, set your lights, and all the other technical aspects that are part of shooting, you should be aware of the jobs and hierarchy of the production team, and how to run the set so that your production footage is captured in an efficient and skilled manner.

Production Personnel

Before covering the actual shoot, let's take a look at the various crew members you might have on your team. The producer(s) may or may not be on set during shooting. They are considered to be part of the production crew and do not do technical work on the set. Post-production people (e.g., the editor) are technical specialists and very much concerned with the actual making of the program, but their job does not begin at this point. An editor would likely be on the set only as an advisor to the director.

Here is a basic list of production personnel you might require during this stage:

- **Director** This person envisions the program and is responsible for bringing that vision to the screen. They will control the activities of the crew and work with actors and other on-camera talent to ensure cohesive and properly portrayed performances. A good director is both right- and left-brained. They must be able to deal with the artistic, creative vision and convey that to the actors, as well as be able to intelligently discuss technical aspects with the director of photography (DOP), special effects team (if they are part of your crew), the lighting department, and other technicians on the set.

- **Assistant directors (AD)** If your shoot is very small (low-budget TV commercial, corporate video, etc.), you might not have assistant directors. But on a larger shoot the ADs are a valuable addition to the crew.

 The first AD usually works with the director to run the set. He or she makes sure that lighting and sound are properly staged and that cast and crew are ready for the shot coming up and are quiet and attentive when the shot is

ready to roll. It is often the first AD's voice you will hear calling the camera to roll and yelling "Cut!" when the shot is finished.

The second AD works on the set to ensure that technical people are in their proper positions, actors for the shot are where they are supposed to be, and those who have no business being there are ushered away before the camera rolls. This person is also responsible for communications and makes sure that two-way radios are properly distributed and tuned to the proper channels. Sometimes they get to hone their directorial skills by choreographing things for extras to do to look natural in the background.

The third AD usually works off set. Responsibilities here include escorting actors on and off the set and in and out of the makeup rooms, controlling public vehicular and foot traffic that could affect the shot, etc. When the second AD radios to "Lock it up for picture!" this person makes sure there is no undue noise that would spoil the sound track.

- **Production assistant** This person is responsible for odd jobs and errands for the director. He or she may also keep track of shooting schedule and shots made, and could also help in breaking down the script into individual shots. In this capacity they are often known as the script assistant.

- **Director of photography (DOP)** Also called the cinematographer on major film projects, this is possibly the next most important person on the set, with the director being the top banana. The DOP is the head of the camera department. It is the DOP's responsibility to commit the visual images to film or tape (or memory card, or disk, or whatever the media may be). As such, they are concerned with what camera and camera accessories are used for any given shot, which lens to use, whether said lens is filtered in any way, and (in agreement with the director) whether the camera is to move during the shot.

The DOP is also responsible for designing the lighting of the set. This includes light positions, types of fixtures and bulbs, diffusion and colored gels, and the placement of shadows. The DOP rarely places the lights. That's where the lighting grips and gaffer come in.

- **Camera operator** Often, the DOP will not operate the camera. That's a job that falls to a camera operator, who is likely in training to be a DOP. This person will be well versed in proper composition and very practiced in camera movement (panning, tilting, dollying, trucking, zooming, etc.).

- **Camera assistants** Again, you might not have need of these positions if your project is small or of the type that only utilizes a small crew. On a large production there can be two or three camera assistants. The first camera assistant helps the camera operator in operating the camera when the shot calls for complex camera moves. Pulling focus means changing the focus setting on the lens during the shot, and it is often difficult—if not impossible—for the camera operator to manage effectively. After marking the required focus settings on the lens with white camera tape and rehearsing the timing with the camera operator, the first camera assistant will pull focus during the shot.

The first camera assistant also makes sure there is an appropriate amount and type of film or tape stock on hand, changes the film reel or tape when necessary, labels and cares for the film or tape that has been shot, and keeps a camera report on what's been shot on which reel or tape.

On a film shoot, the second camera assistant is also called the clapper/loader, as this person is responsible for loading raw film stock into magazines before passing it on to the first camera assistant. The "clapper" part of the name comes from the responsibility to fill in the information on the slate and hold it in front of the camera at the beginning of each shot as an identifier of the shot being made. In film, the clapper stick on the slate must be snapped smartly onto the slate to establish a synchronization reference for both the camera and the (separate) sound recorder. As the video camera records both picture and sound, the clapper does not usually need to be clapped when making a video project, but it often is clapped because it's just whoopee-darn fun (or if a separate audio recorder is being used).

The second camera assistant will also be in charge of moving the camera to each new position in the set and must also clean, pack, and care for the camera during location changes.

If there is a third assistant, it will usually be a junior trainee who can be given any tasks that the others don't normally have to do, such as sweeping out the camera truck or polishing the tripod handle.

- **Gaffer** This is *not* an abnormally short person ("Just a little gaffer??"). The gaffer is the head of the lighting department and is usually a licensed electrician. This person cares for the lighting equipment and is responsible for making sure the proper fixtures and accessories are available and there is adequate electrical power for the set. He or she also directs the lighting grips in mounting, focusing, and trimming the lights to the DOP's specifications.

 As this person can often be seen carrying a large roll of duct-like tape on their belt to help in affixing lights and other equipment, the tape is called "gaffer's tape" or just "gaff tape."

- **Best boy** This person was originally an assistant to the gaffer and so is second in command in the lighting/electrics department. Today there can be a best boy position in many other departments as well, and so the term has come to mean "second in command."

- **Grips** Grips are people who lift, carry, move, set up, and trim the lights, set pieces, and camera equipment. Far from being just the muscle to move equipment, the grips are also usually quite skilled in things mechanical—they're the type of person you want as a neighbor when your car breaks down. Given a coat hanger and a roll of gaff tape, he can usually fix it. Often, grips are called upon to fabricate or modify a piece of equipment (e.g., to mount a light where normal mounting hardware won't work) or fix something that's been broken.

 Lighting grips deal mostly with lighting. Camera grips care for the camera. Dolly grips maintain and steer the camera dolly during a shot, and set grips build and dismantle set pieces.

- **Sound recordist** The sound recordist's job is to choose the proper microphones and recording equipment to record the best possible on-set sound (dialog and ambient sound). While this position doesn't take as many years of experience to master as the DOP's trade, it still holds a very important position in the production team. The sound recordist often has to deal with poor acoustics and the wrong kind of background noise to get a clear track. They must have enough electrical knowledge to be able to deal with electrical hums, hisses, and other unwelcome sounds that can ruin a sterling performance.

On film productions there will usually be at least two sound people. One will be the boom operator (holding the microphone on a boom pole over the actors) and the other will be the recordist. Sometimes there will also be a two-person team for video productions, but if you are only using a single microphone plugged directly into the camera, one person may be enough.

- **Unit manager** The unit manager is just what the name suggests. This person manages the unit. It's actually not a technical position directly concerned with the production, but a large unit of people and equipment must be managed effectively so that the whole machine can operate smoothly.

 The unit manager reports directly to the producer and keeps track of schedules, budget, crew salaries, transportation, accommodation (if the shoot is out of town), and facilities such as crew meals (finding a set-up area for a craft services catering company), toilet facilities on location, etc.

- **Continuity person** The continuity person keeps track of what has been shot with an eye to consistency to avoid jump cuts or errors. If you've ever seen an actor's costume change in some way from one shot to another in a continuous scene or mussed-up hair suddenly become neat in the next shot, continuity errors have been made. This person attempts to keep errors of this type to a minimum. This job is often also called script supervisor.

- **Talent and extras** Talent is the word we use to refer to the actors (even if they have none). These are the people who assume another, often fictional identity and play it out as if real. Sometimes specialty talents like TV reporters, magicians, dancers, etc., are played by actual reporters, magicians, and dancers so that actors don't have to be trained in these special skills.

 Extras can best be described as atmosphere people. They are the bystanders that are on set to make a scene look real. They are distinguishable from actors in that they usually have no lines to speak or any overt physical acting to do. They're just crowd. As such, they don't get paid as much as the actors, sometimes doing it just for the fun of being seen on camera, and a good meal or two. They, like the actors, will often be asked to repeat their actions over and over for various takes and camera angles ("woman with baby carriage walks past" again and again).

 So now that you know who does what to whom on the set, it's time to set things up!

Setting Up Your Shoot

Eventually the big day arrives! The first shooting day! You will have already booked rental equipment and found your location and crew during the pre-production stage.

When you arrive at the location or studio where the shoot will take place, the first order of business will be to scope out a good staging area. A staging area is where the bulk of your equipment will be stored until the individual pieces are needed. This should be a place where the equipment that is not currently in use won't be in anyone's way but is easily accessible when required. It also should offer a reasonable amount of security if the location is a public area. In this case you might want to assign one or more of your crew to watching over and preparing equipment for use.

If you haven't already done this during a previous location survey (and you should have), you will determine the position and angles for the first scene. If you're working outdoors, you might have to take into account the direction that natural light is coming from as well as setting and background. That's why a survey ahead of time is often important. It'll save you time during the shoot. If you are using a public or private interior location, you will also likely have researched the power requirements and availability.

Once your equipment is in the staging area, the set will be arranged and perhaps tape stuck to certain parts of the floor to indicate where set pieces are to go and show the actors where they will be at certain times during the shoot. These are called spike marks for the set pieces and T-marks for where the actors are to stand. Any easily seen sticky tape will do. A rental agency can sell you what's called camera tape for this purpose, which is a roll of white or colored cloth tape about an inch wide.

Next the scene will be populated with any set pieces (desks, tables, chairs, couches, etc.) that need to be in place to make the set appear as it should per your script. Set decoration will be added (wall hangings, flower vases, a telephone and some magazines on the coffee table, etc.) and props will also be placed. Props are those things that will directly help to tell the story (the ashtray she will throw at him, the trashcan he'll kick over, the fire poker she'll hit him with, and the gun he'll take out of the desk drawer and shoot her with).

Before we're ready to shoot, the lighting needs to be placed. Sometimes the DOP or the head lighting technician will request the actors or stand-ins be available for this task. The lighting can now be set up specifically for a character's position in the set. The DOP will take several light readings from various positions in the set to ensure the proper balance between light and dark areas. Perhaps an all-over reading will be taken if the set is merely washed with an even light. This is called broadcast lighting.

Having scheduled a certain time to set up the first shot, the director (or first AD) will make sure that everything is ready on time. You, the director, can now walk your actors through their roles for this shot. Again, enough time must be allowed for blocking and rehearsals.

Finally, when you are ready to make the shot, you might inform the first AD who will, in turn, notify the second AD, who will radio the third AD to "Lock it up for picture!" Yes, it really does go through this chain of command. Just like a military unit.

Then, the director (or first AD) will call for "Quiet on the set!" When everyone is paying attention and is quiet, we address the camera operator with, "Camera ready?" The camera operator will respond with, "Ready!" (or not, if that is the case). "Sound ready?" is next, to which the sound person responds with "Ready" (or not). Then the director or first AD will call out, "Roll camera!" to which the camera operator must reply "Rolling!"

The next command is, "Slate it!" or sometimes just "Marker!" upon which the slate person (second camera assistant, clapper/loader, etc.) will hold the slate in front of the rolling camera such that the information on it can be clearly seen by the camera, and vocally call out the scene or shot number and take number (e.g., "Scene 7, take 2."). The slate clap stick will now be snapped against the slate (or not if you're not recording sound, or if you're shooting video, which doesn't require the clap stick). The slate person now beats a hasty exit from the scene, the camera operator reframes the shot (if necessary), and then the camera operator calls out "Framed!" at which time the director pauses for a second or two for editing purposes and then calls "Action!"

After the director is certain that the action for this shot has played out, he or she will pause again briefly and then call "Cut!" Then, it's on to the next set-up and we start the whole process all over again.

So, to recap the commands, they are:

Director or first AD: "Lock it up for picture!"

A pause of a few seconds to give the third AD time to quiet the people or traffic that is just off-set.

"Quiet on the set!"

"Camera ready?"

Camera operator: "Ready!"

Director or first AD: "Sound ready?"

Sound person: "Ready!"

Director or first AD: "Roll camera!"

Camera operator: "Rolling!"

Director or first AD: "Slate it!" or "Marker!"

Slate person holds up the slate and calls out the scene or shot number and the take number. After the slate person leaves the frame, the camera operator hastily reframes the shot for the beginning of the action.

Camera operator: "Framed!"

A slight pause.

Director or first AD: "Action!"

The action for the scene is played out and then, after a few seconds are left at the end for the editor's benefit: "Cut!"

If you are working in film and you feel this was a good take, you will also ask the first camera assistant to "check the gate," which is done in film projects to be sure there were no hairs or dust in the camera's mechanical gate that could otherwise go unnoticed and spoil the shot. It is not necessary to do this when using a video camera. Smaller shoots may do away with some of these conventions. It's really up to the director to determine the rules of the set and convey them to the crew.

Set Etiquette

The term "set etiquette" refers to the professional attitude of the people who work in the production end of this industry. Everybody does their job efficiently and enthusiastically. Without a structure of etiquette, a large shoot would be chaos. As mentioned earlier, it's almost militaristic in its precision and specific command set. Film schools and motion picture unions run courses on set etiquette as a prerequisite to being allowed employment in that industry.

Here are some of the main tenets:

- Workers on a set always show up on time (or even a bit early) and ready to work.

- Each person does only his or her work. If you aren't busy and wish to help someone in another department do their work, ask them first if you can help. Don't just pitch in. It might seem that you're doing them a favor, but it could go against their work ethic (or the union's).

- No one, except possibly the DOP and maybe the first AD, will bother the director with their ideas of how a scene should be staged or how the set should be run. If you feel you have a valid suggestion or complaint, take it first to your immediate supervisor or (if you're sure this is appropriate) an assistant director.

- When the "Quiet!" command is given, you immediately fall silent and still, even if you're halfway through the punch line to a killer joke.

- For safety reasons you must be more careful of wires, cables, grip stands, and other dangers that lurk in the shadows behind the camera than you would have to be in many other jobs. Because of the constant changes made on a set, cables aren't usually dressed out of the way, and a grip stand set up in a certain configuration can take an eye out if you walk into it.

- Always try to use standard industry terminology to communicate with other workers on the set.

- If you have anything bad to say about anyone, DON'T.

- No bad language or offensive jokes on the set.

- If in doubt as to what you should do, ask.

- Do your job willingly and to the best of your ability.

It's pretty much common sense.

Smaller Shoots

When you are filming a documentary, TV commercial, a small film for a festival entry, etc., you may not have the complexity in your script to warrant a large crew. When you are on this type of shoot, you can be a little more relaxed on the command hierarchy and even set etiquette. You will, however, be wise to make sure someone's in charge (the director) and that whatever crew you are working with will follow the lead of that person. Commands such as "Roll camera," "Camera rolling," "Action," and "Cut" should still be used to make sure that everything is being shot properly ("What, did you mean I should roll? I thought that was just a rehearsal.").

Cover Shots

I've worked with the same camera operator for over 30 years while shooting corporate videos. Because we have worked together so often, I know that all I have to say after we have shot the closer scripted shots is, "Cover this off, Chester," and walk away to discuss the next set-up with my client. Chester knows exactly what shots I need as "cover" for the sequence we were just shooting.

Here's an example: We have just captured the scripted shots of a worker at an assembly line doing his job. In the script the narrator says something like, "At XYZ Company our workers are committed to safety in the workplace as well as maintaining the best quality in the production of our products." The script calls for one wide, establishing shot and one medium shot of the worker assembling something.

As these two shots may or may not constitute enough time to comfortably allow the narrator to finish the line, I ask Chester to "cover it off" as I walk away to prepare for the next set-up. Chester will then compose several other shots that can be used in editing to pad for time and/or make the sequence a little more visually interesting.

He'll shoot another couple of medium shots of the worker from different angles, a close-up of the worker's face (to show how attentive he is to his job and the fact that he's wearing safety glasses), a close-up of his hands doing the assembly of the product, and whatever else that looks like it could be useful. If the worker is wearing safety gloves, the close-up of his hands could be used when the narrator mentions safety. While most of this will not be used in the final edit of the program (called "leaving it on the editing room floor"), occasionally it is very useful—if not in this sequence, perhaps

in a collage of shots, set to music, that might be used at the beginning or during the end of the video.

Tape is cheap, so the only reasons not to take cover shots are when you are sure they could never be useful or the amount of time you have to shoot is too short to allow covering each set up. In Hollywood, the cover shots are often left for the AD to direct to hone his or her skills as a director while the lead director is busy elsewhere. Sometimes cover shots are made by a second unit (a whole other set of equipment, crew, and director) whose job is to do cover shots and shoot less important material at locations that the main director needn't attend.

Shooting Ratios

It's often said that the ratio of tape shot and the final length of the finished program is about 5 to 1. I scratch my head when I hear this, wondering who came up with this figure. I've worked on projects (both my own and for others) that had ratios that were as high as 35 to 1 and as low as 1.5 to 1 (that's scary!). 5 to 1 is an approximation, but you should consider it when shooting your project. How much footage is too much and how much is too little is highly subjective and usually based (over time) on experience. Most novice filmmakers don't shoot enough footage over and above what's scripted and then wish that they had, while some beginners are afraid not to capture absolutely everything (like a friend of mine who captured over 36 hours of material for a proposed one-hour documentary).

So, the suggestion here is don't shoot too much, but make sure that you have more than you'll need. You figure out how much you need with experience, and even that isn't a guarantee you'll always have enough.

Peripheral Shooting Equipment

There are many pieces of equipment, over and above the obvious camera, tripod, lights, and microphone that you might find beneficial while shooting. I always like to have a slate to mark each shot that's taken. A standard motion picture slate will set you back between $50 and $100, depending on where you buy it. They're made of heavy plastic with a wooden clapboard mounted on the top (see Figure 8-1).

FIGURE 8-1 Professional slate, properly lit, focused, and framed

The clapper is used to synchronize picture and sound when the sound is being recorded by an audio recorder that's separate from the camera. When you are recording your sound directly to the camera you don't need to use the clap stick (but we all do because it's fun).

While you can write on the plastic surface with a dry-erase marker, eventually the surface of the slate will get grungy and you won't be able to erase all of your marks. I suggest applying a piece of overhead transparency plastic over the slate and tape it along the edges. This works well with dry-erase markers and can be replaced when necessary.

Film people often use white camera tape for some information on the slate. They'll stick bits of tape with various numbers and letters written on them to the back of the slate so they can quickly take a number or letter off of the back and apply it to the front of the slate and then replace them when necessary. This also protects the slate.

For video shooting where sync is not important, you can get away with a slate design printed on paper, mounted on a piece of stiff card stock, and covered with a piece of clear plastic (overhead transparency plastic). This can now be marked with a dry-erase marker pen.

Marking each shot will save you having to slow down, look, and listen critically when you're logging footage. Often, you just want to zip through shots quickly, and having a visual reference as to shot number and take number makes it a lot quicker to do so. In addition, make sure when you shoot the slate that it is well lit, in focus, and large in the frame.

If you forget to slate a shot at the beginning, you can do a tail slate by holding the slate upside down. It means that the information on the slate is for the previous shot, not the next shot. Take a good supply of dry-erase markers and some paper towel to use as erasers.

A fair size field monitor is always a good idea if your shooting situation allows for the extra equipment load. Often set up on a folding table near the camera, it will allow the director and others to really see the shot properly and watch the action critically during a take. Many rental monitors come with sun shields to make outdoor viewing easier.

The LCD screen on the camera can often be swiveled into a position that will allow the director to see it while the camera operator uses the diopter viewfinder, but the 3.5-inch LCD screen is not really large enough to get a good look at the shot, and many cameras don't allow you to run the diopter viewfinder and the LCD screen at the same time.

If you are shooting a "stand-up"—that is, a person standing in front of the camera and speaking directly to the viewer—you might want to consider either cue cards or a teleprompter (see Figure 8-2).

The trick with cue cards is to hold them as close to the camera lens as possible so that the performer's eye line still appears to be toward the camera. For this reason we usually make our cue cards from stiff card stock that is no wider than 12 inches but up to 36 inches long. You write narration to be read in very large letters (at least 2 inches) with a heavy felt pen.

The cue cards are held by a camera assistant or production assistant right up to the side of the lens (*almost* touching it) and are pulled slowly up to match the speed of the speaker while trying to keep the text being read at lens level. Often, a second cue card person is standing by to take the used cue card when the cue card holder is finished with it and ready to display the next card in the stack they are holding. It takes some practice between the performer and the cue card person to get the proper speed while making sure that the performer appears to be looking at the camera. It's a good idea not to make your shot any closer than you think necessary. The tighter the shot, the easier it will be to see the slight off-camera eye line.

FIGURE 8-2 Using cue cards

If the budget and the amount of equipment you can carry allow it, the best way to ensure a convincing read from your performer is to use a teleprompter. A teleprompter (or "autocue") is a device mounted on the camera tripod that places an angled piece of two-way glass (semi-silvered mirror, like they use in police line-up viewing rooms) in front of the lens in such a way that the camera can shoot through the glass and "see" the performer, but the performer cannot see the camera lens. The performer only sees what is reflected on the mirror side of the glass. The reflection on the mirror is text from a monitor that is mounted at the correct angle to reflect the image so it can be read by the performer, as shown in Figure 8-3.

The text comes from a laptop computer hooked up to the monitor and using special teleprompter software to scroll the text at variable speeds. The software will usually allow for editing the text, changing the text size and color, and reversing the text so that when it is reflected off the mirror it will not appear backward to the performer.

FIGURE 8-3 How a teleprompter works. (1.) Camera. (2.) Shroud. (3.) LCD monitor. (4.) Two-way mirror. (5.) Image of subject is picked up by the camera. (6.) Reflected text can be seen by performer.

Any glass shop should be able to provide a semi-silvered, two-way mirror if you want to build your own prompter, but they will usually only be able to supply quarter-inch glass with a 50 percent mirror finish, which can darken your image. This might be okay if you have sufficient light on your set. If you do build your own, you might have to buy dedicated prompter software. There are several good websites that you can find by using a search engine and searching for "teleprompter software."

The advantage of a teleprompter is that the performer's eyes are looking exactly at the lens even though he or she cannot actually see the lens—only the text they are reading. Figures 8-4 through 8-6 demonstrate teleprompters in use.

A few other pieces of peripheral gear you might want to consider having with you are some foam core board for bouncing light or creating shadows, a roll of gaff tape (or good duct tape), a grip stand or two (sometimes called a C-stand), perhaps some flags for cutting light (they mount in the grip stand), and extra power and audio cables.

Last Word

If I've learned anything in my 30-odd years in this business (good grief, has it been that long?), it's that you mustn't rush through the setting up of lights and determining your camera angles and shooting. Properly done staging and lighting will make your

FIGURE 8-4 Notice that the text is visible on the teleprompter mirror. (Creative Commons)

FIGURE 8-5 Prompter with cathode ray tube (CRT) instead of LCD screen

FIGURE 8-6 Yours truly with prompter cam on a shoot

video look much more professional than hastily plopping your lights and camera down just so you can get the shots in the can quicker.

Also, it's important to critically analyze each shot as it's made—or play each one back before moving on—as it's easy to miss small details that might cause your "best take" to look less polished than you'd like. So, make as many takes as it takes. Beginners will often overlook the importance of careful set-up and the number of takes necessary to do the job right.

If you follow this advice, the number of takes you make will likely be considered, by professional standards, to be way too many. But, you'll get better at determining the number of takes you need as you gain more experience in the field, and you'll soon be able to capture what you need with less shooting.

So…have a great shoot!

9

Post-production

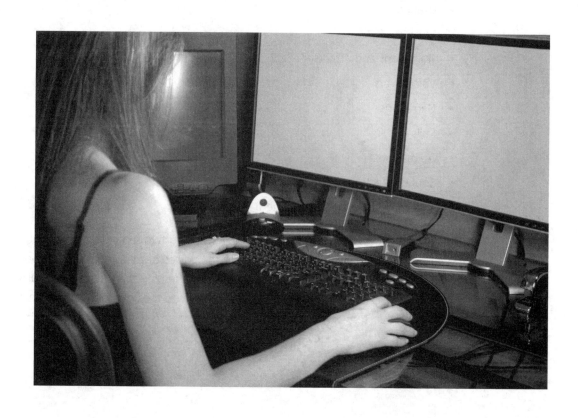

Get out your scissors and let's start cutting! Okay—scissors haven't actually been used since the very earliest edited films. But, this is where the magic happens!

Bringing It All Together

The editing process (known as post-production) is where you gather all of the material you need to complete your program and piece it together to form a smooth-running, cohesive, and complete product.

Editing Your Project

While we've already looked at the possible elements your production may require, I'll just give a quick list here for review. I've tried to make this list follow the order of most to least likely, but it really depends on your script requirements. Your production might not need all of these elements.

- Original footage (obviously)
- Graphics
- Music
- Transitions and effects
- Voice-overs
- Narrations
- Stills
- Animations
- Sound effects
- Automatic dialogue replacement (ADR)

By the way, voice-overs and narrations can be considered two separate types of sound tracks. If, for instance, your program calls for the voices of people that you have interviewed to be heard while showing a picture of something that they may be talking about, this is a voice-over, while narration always refers to the voice of a professional narrator telling the story. Sometimes, these terms are used interchangeably.

ADR, if you will remember, is the process of replacing the voice of an on-screen character with a voice that has been re-recorded in a studio later by the same actor(s). The trick, of course, is to synchronize the new sound track with the lips of the person in the picture.

How to Edit

Trying to learn how to edit by reading a textbook like this one is like learning how to play the piano by reading a textbook on music. While the book can give some useful theory, it can't really teach you the technical, hands-on part. You just have to do it. Unless you have an instructor sitting with you, the only way to learn effectively is to

- Read the manual that came with your editing software thoroughly.
- Tinker with the software to learn all the functions before you actually edit.
- Roll up your sleeves and begin, with the manual close at hand!

So, in this short chapter I will define some components of an edit and dole out some pearls of wisdom that should help you when you dive into the editing process.

Available Software

When you buy a new computer today it will often come bundled with video editing software. This is a good place to start your editing career if you are new to this field. While these programs were, at first, very simple and you would likely grow out of them quickly, today's "bundled" software is actually pretty good. You can do a lot with these beginner's programs. Eventually, however, you will find there are many things that you cannot do with the standard, consumer editing programs, and you'll want to move up to something a little more—or, if you can afford it, a lot more—professional.

While there are a great many available products you can purchase, the following short list will give you a good starting point for researching what will best suit you:

- **Premier** Available in both consumer and professional versions, this software is quite good, and while it was originally trailing the other leaders in professional standards, its current professional version is running neck and neck with the other pro programs. Premiere is available only for Windows.

- **Avid** Available in both software-only and hardware-based versions, this industry standard was used extensively for television and movie post-production from the early days of nonlinear editing. Originally only high-end post houses could afford it, but it is now competitively priced. Avid is available for both Windows and Macs.

- **Final Cut Pro** Until recently, this high-end editing software for Mac computers used to only be sold in two versions: the professional Final Cut version and the "light" version called Final Cut Express.

 The professional version consisted of a suite of programs that, in addition to including editing software, a compression program, and a killer text generator, also featured a professional DVD-authoring program, a color processing program, and a great, fun program for creating motion backgrounds and title sequences. This professional Final Cut had been a staple in the motion picture, television, and corporate video trades for years.

 Final Cut Express was used for corporate videos and was reasonably priced so that consumers could use it too. It had fewer features and only a limited number of associated support programs, but it was still a very powerful choice for video editing.

 Both versions have now been replaced with Final Cut Pro X (its designation as of this writing). Many professionals feel that this new version has been "dumbed down" and does not have all of the features and functionality that the original had. There definitely are some zippy new features that make it a worthwhile investment, but because it won't open project files from older versions and because the interface has changed so much, it is not getting the nod from professionals that Apple might have liked. At least, not yet. Apple is already satisfying the pros by reinstating some features that they had originally written out of this version.

 For those used to the old FCP, the learning curve is a bit steep, but for newbies, it's not any harder than learning any sophisticated software from the ground up. Only time will tell if the new Final Cut will be fully accepted in professional industries.

 While the original Final Cut was a suite of programs that sold for around $1,500, this version is only $299.99. A very good bang for the buck!

After you've had a look at the features and prices of these upper-end programs you should really continue your research on the Web and by talking to knowledgeable sales reps to find other editing software choices. There are scads of professional video editing programs out there! Do your research! It'll pay off by allowing you to get the features you need at a price you can afford.

A Short History

The technology involved in the early days of video editing was quite different than it is today. Not only is the equipment much better and faster now—the whole way in which video is edited has changed. In the early days of 2-inch videotape (late 1950s and early 1960s) videotape editing was literally done with a pair of scissors (ouch!). Of course, such brutal chopping and hacking would break the control track, which keeps the picture track scans in synchronization with the spinning video playback heads, and when the video was played back the picture would destabilize when the edit passed over the heads, as shown in Figure 9-1 (see Chapter 1).

Therefore, it could not really be used to edit a program. It was only used to string multiple full programs together on one videotape. This edit between programs was never shown on air.

FIGURE 9-1 A destabilized control track looks like this on screen.

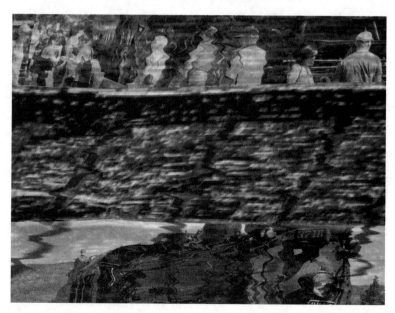

Television programs in those days were mostly shot and edited on film before being transferred to tape via a machine known as a telecine chain. Two 16mm projectors were focused through a beam splitter so that both images were focused on the lens of a video camera using an aerial image process. An image focused on a point of space without a screen would ensure that no screen grain was visible. Figure 9-2 visually depicts the process.

The only other way of bringing a program to air was by live television. In those days several programs were shot in a studio with multiple cameras, and live switching was done between them. Dramatic programs had to be rigorously rehearsed and carefully staged so that the whole half-hour or one-hour show could be shot live. When a

FIGURE 9-2 Overhead view of a telecine chain. Projector 1's image is bouncing off the 50/50 mirror (beam splitter) and focused on space in front of the camera. When we change from projector 1 to projector 2 during a multireel movie, projector 2's image shines straight through the mirror glass and is also focused on the aerial focal point.

videotape recorded this "live" program, the term "live to tape" was coined. Using that method, if the studio shoot had to be stopped partway through because of an error (actors messing up their lines or technical difficulties), the entire program had to be reshot from the beginning, as there was no reliable editing process for the videotape.

Later (early to mid-1960s) the tape-to-tape method of editing was invented that allowed synchronization of playback machines with the recording machine. My first editing suite boasted one playback machine and one editing recorder. The limitation was that I could not do transitional effects such as the very common dissolve. In order to do a dissolve or other effects between two shots, you needed two playback machines that were synchronized with each other and the recorder. A video mixer between them was used for the effect. Then, if you had all of your even-numbered shots on player one and all of your odd-numbered shots on player two, with each feeding its video signal into the video mixer and the mixer's output tied into the recorder, you could dissolve from player one to player two.

At first the editor would have to be on his toes and make sure that he activated the dissolve manually, usually by pulling or pushing a small dissolve lever on the mixer. Later this was preprogrammed into memory in the mixer so that the dissolve (or whatever transitional effect was needed) would happen automatically when required.

This method was used successfully for many years, but the main drawback was that you had to edit your entire program in a linear fashion (shot 1 followed by shot 2 and so on to the end of the program). Furthermore, if you wished to go back to, say, the middle of the program and replace, delete, or add a shot that would make the full program either longer or shorter, the rest of the program had to be re-edited from that point to the end (Whew! What a lot of work!).

In the mid to late 1960s the CMX-600 editing system was invented. This marvelous, computer-based device automated the editing process such that every edit was recorded into what is called an edit list. The list would record every shot's in point and out point in the edit as well as transitions. If the situation mentioned previously arose, at least the computer would take over the editing from the part you amended through to the end. But, it still took a lot of time because it was still being recorded to linear videotape.

The CMX-600 was run by a computer, which, in those days, was hideously expensive so only television networks and large-scale production houses could afford them. Finally we began using smaller, less expensive computers to record the video onto the computer's hard drive and manipulate it in a nonlinear way. This important innovation happened around 1980.

The term nonlinear means that you don't have to edit from shot 1 to shot 2, etc., but can start in the middle of the program if you wish and move back and forth. The best analogy is word processing software that allows you to cut, copy, paste, and delete or add material within any part of your document. And the best part is that if you make a change to the program length from within the program, you don't have to do all the work of re-editing the rest of the material to the end. If you make the program shorter, the software will close the gap and pull everything back to the edit point. If you make the program longer, the software will "push" everything else down the time line and connect it to the final edit of your change. Way cool!

To those brought up in the computer age and the age of nonlinear, this might not seem too impressive, but if you consider all of the hardships that went before, it's freakin' amazing!

The Basics of Editing

The first step in editing is to capture your original footage, sound, stills, etc., to your hard drive. Try to organize these elements in a file system that makes them easy to find. Most editing software will create a storage area on your drive as soon as you create an edit file (often called a project). You usually can create new folders within the main storage area to store video, sound files, stills, animations, sound effects, etc.

A traditional edit process can go through three main steps:

- **Assemble edit** This is where you make very rough in and out point decisions and then plop the shots on the time line in program order. This edit still needs a lot of work, but it enables you to watch your edit unfold quickly and give you an idea of the pacing that you want. If you stop to niggle around with each edit to perfect it, you might lose the sense of timing you are attempting to build into the edit.

- **Rough cut** After you've watched your assemble edit you will have an idea of the corrections to pacing you must make and other technical mistakes that might have crept in. These are corrected in this stage. Normally you won't add extra elements unless you need them to determine pacing or enhance the understanding of the story for a preview screening to clients or the director.

- **Fine cut** Final edit problems are overcome and transitions added between shots where required. Music, graphics, and special effects are added that you might not have bothered with in the first two stages. All final tweaking, including sound mixing, image enhancement, and color balancing, is done now.

That is how editing has always been done, and many editors follow this method. However, most editors in today's nonlinear times begin with the rough cut. I usually start somewhere between the rough cut and the fine cut in that I try to make a finished program as I go. Then I go back and tweak a bit to complete my fine (and, hopefully final) cut. It's just my way of working. Every editor has his or her own method that suits them best. You will too.

I must warn you, though, that if you are new to editing you might not be wise to go to the almost finished method first that I use. It takes years of experience to be able to work quickly and accurately to an almost finished product on the first edit.

Components of the Editing Environment

All editing software is different, although most professional systems have many things in common. I'm using an older version of Final Cut Pro for examples in this book because it is an industry standard, shares much of its work flow and structure with other professional programs, makes it easier to understand the concepts portrayed here than if I had used Final Cut X, and is the software I am most familiar with. Users of other editing software may see similarities with this version of Final Cut, but there will undoubtedly be many differences as well. The basics of the Final Cut software will suffice here as an example for teaching purposes.

When you first open the program, you are confronted with a screen that is divided into six main components. Figure 9-3 shows the standard layout, but there are several other layouts that you can choose from depending on how you want the screen to look.

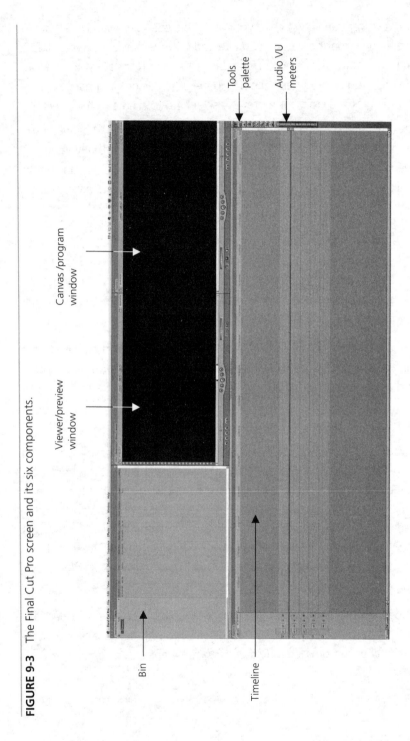

FIGURE 9-3 The Final Cut Pro screen and its six components.

FIGURE 9-4 The bin

There will be a window where all of your elements are represented, as shown in Figure 9-4. In Final Cut this is called a bin (after the wooden bin that editors hang film clips in when editing actual motion picture film). I said that the elements are represented because the icons you see are not your actual elements, but rather pointers (or aliases in Macintosh parlance) to the video clips, sounds, pictures, etc., that are saved on your hard drive. Nonlinear editing is nondestructive, which means that if you delete an icon from this window you are not deleting the file from your hard drive—just its icon in the bin that points the software to your actual element. It can easily be brought into the bin again.

The bin also includes indicators of your various sequences or time lines. You can make several sequences for different cuts of the same project or to work on pieces of your project outside of the main edit. You can make as many bins as you need to separate different types of clips in your project.

Next there will be a preview window where you define the in and out points of your clips and make visual or audio adjustments (more on adjustments later), as shown in Figure 9-5.

There must be a program window where you are able to see the edit playing from the time line. In Final Cut, this is called the canvas (see Figure 9-6). In this window you can adjust the size, cropping, and shape of your clips as seen in playback, as well as create animations of your clips that can't be done with the effects that are included in the software. This includes controlled spins, zooms, and side-to-side or up-down motions.

The time line is where your project is assembled together (Figure 9-7).

FIGURE 9-5 The viewer (preview) window

FIGURE 9-6 The canvas (program) window

FIGURE 9-7 The time line

The tools palette (see Figure 9-8) includes the editing tools that you use to alter clips on the time line. Tools such as a selection tool, the cropping tool, and a zoom tool to enable you to zoom in to magnify a portion of the time line or zoom out for an overview of the time line, and even a razor blade tool (in some programs represented

FIGURE 9-8 The tools palette

as the dreaded scissors used in early editing) that allows you to make cuts in the clips on the time line. (It's okay, though, as you won't affect the control track.)

The volume unit (VU) meters (see Figure 9-9) are used to help you see how loud or soft your sound is and whether it is peaking too high, which may cause distortion. In Final Cut the maximum peak of the loudest sounds should come up to between −12 and −6 decibels (Db).

FIGURE 9-9 Audio VU meters

Okay, so much for the screen layout, windows, and tools available for editing. As mentioned before you will first want to capture your footage and import all files to the storage area on the hard drive that is dedicated to your project. Many of my students insist on capturing an entire tape—good takes, bad takes, shots that aren't even required in the finished program, the time they left the camera running by mistake, etc.—and then chopping that very long shot up during editing. This is messy, clogs up your hard drive with unnecessary information, and makes editing a slower process.

It may take a bit more time initially, but the best method is to go through the tape shot by shot, take by take, and define in and out points for only those takes that you believe you will use, plus maybe a few safety takes if you are unsure which take will work best. This will make editing easier in the long run. You can either capture shots as you find them (see Figures 9-10 and 9-11) or just create an edit list of all the ins and outs and let the computer take over and automatically capture all of the shots you've defined while you do lunch with the money man who will finance your next epic.

FIGURE 9-10 The log and capture window

FIGURE 9-11 Capturing footage

Now you have all of the relevant takes of each shot captured onto your hard drive. Once that's done, the actual editing can begin.

Starting to Edit

When you begin the actual edit, you define the in point and out point of the first shot or graphic you are going to plop onto the time line. You should capture each shot in its complete form (slate, all action, and end run-off). Then you will need to define the point at which your desired action is to begin and end in your final program. Some programs insist that you do all of your trimming on the time line, but most professional software will let you do this in the preview window, or whatever your software calls it, *before* putting it on the time line. This makes trimming the ins and outs a lot easier.

Let's go through the edit of a short program. To start you will call the first clip into the preview window and using the controls for that window, define an in and out point

for the required action or for the amount of time you want this image on the screen. That clip is now sent to the time line. Either drag it there (I assume you are familiar enough with computers to understand clicking and dragging), click an on-screen button, or use a keyboard shortcut.

Ta da!!! First edit successfully completed! Then do the same with successive elements to install them on the time line.

If all you want to do is string a bunch of shots together, editing involves no more than repeating this process with each element from beginning to end. However, the reality is that there is much more work to be done in most projects. What we have accomplished here is called an assemble edit, as described earlier. Figure 9-12 shows a project that has been assembled from beginning to end, but it isn't finished yet.

What next? Let's put a title at the beginning of our program (the magic of nonlinear editing). After creating the title (or having imported it from, say a Photoshop file)

FIGURE 9-12 The initial assembly

we can define its length in the preview window, place our play head at the very beginning, and use an insert command to push the rest of the edit down the line to allow space for the new element. Before we show you a picture of that let's also put some opening music in place. The music file is also transported to the preview window and the in and out for it are defined, as shown in Figure 9-13.

If the music is timed to run under the beginning of the video footage, you will want to use a new set of tracks for this (two for stereo sound) so that you don't overwrite the sound from your video footage. You'll notice that the music only plays for a few seconds (enough time to get through the title and play a few seconds into the first part of the program) and then stops dead—probably during the song. Don't worry about this now; we'll fix it later.

You now might want to play through the title into the program to make sure that the timing is right and the music matches the mood of the first scenes. Eventually, you will

FIGURE 9-13 The assemble edit with title and music.

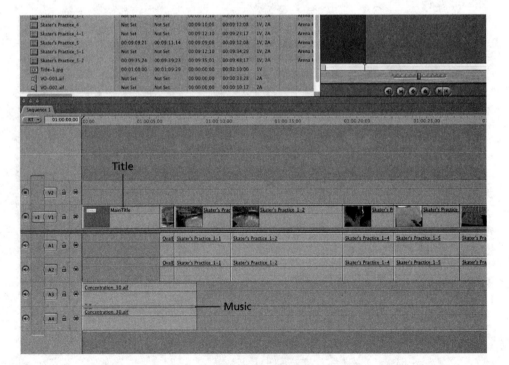

have your edit built to a point where you will want to watch the whole program (either all at once or in chunks) to determine if the pacing is right, there are no faulty edits, and that the story is being told well.

There are many ways of editing. Everyone will choose their own working method. I prefer to put in transitional effects as soon as I have previewed any part (sequence) of the edit enough to know that it's working. Other editors wait until the entire program is complete (technically and storywise) and then insert all of the effects at once. Whatever turns your crank. Likewise, most professional programs will allow you to perform the same editing task in several different ways. For instance:

- To put a clip into the preview window, you can drag it or just double-click it.
- To move a clip to the time line, you can drag it, click the insert button, or use a keyboard shortcut (COMMAND-F9 in Final Cut on a Mac computer).
- To do a fade out in Final Cut, you can use a dissolve effect and dissolve to an empty space on the time line or to a black slug (a movie file that is just black video), or use the pen tool to "rubber band" the shot from 100 percent visible to 0 percent invisible.

Once you learn the various methods, you will choose the ones that suit your working style.

Back to the edit: In Figure 9-14 you can see that I have added transitional effects, a narration track, and music for the ending. I've also included some credits at the end before the final fade-out. It is not the purpose of this book to teach exactly how to perform each function in Final Cut or any other editing software. You'll have to learn that yourself.

Now let's have a look at some highlights of this edit. The numbers in the list below correspond to the numbers in Figure 9-14.

1. Notice that I've used the "rubber band" method to fade up from black at the beginning and to fade to black at the end. By placing points on the overlay lines of the video track and both the left and right sound tracks, and pulling the appropriate points downward, we can fade the picture and/or the sound tracks up or down.

FIGURE 9-14 The finished edit with some interesting highlights. Numbers correspond with description in the text.

2. I've also used rubber banding to fade the music out slowly as the first live shot begins.

3. If you look at the sound track and the picture track of this shot you'll notice that the sound carries on into the first part of the next shot, while the next shot's audio is missing until the overlap ends. This is called a split edit or (in this case) an L-cut.

4. Another example of the split edit is where the incoming shot's audio begins over the last few seconds of the outgoing shot's video. This type of split edit is called a J-cut.

5. A narration track has been added on another set of tracks. Notice that the sound of the video clip above it has been lowered in volume by pulling down the overlay line so that the narrator's voice isn't drowned out.

6. Notice one shot has a title icon on the time line above it? This is so the title will superimpose over the shot. The title is set to fade in with the shot and fade out before the shot ends. I used the dissolve tool here.

7. Some transitions are merely cuts, some are dissolves, and some utilize other types of transitional effects. You must be careful what type and how many transitions you use in a sequence. If you use too many different digital, animated effects your audience will think you're just a gadget freak gone mad. Here's an idea of when to use an effect:

- **Straight cut** Most of the time in most productions
- **Dissolve** Denotes a change in location or time in your story
- **Dip to black** Separates two sequences. The picture rapidly fades out to black and then quickly in again to the next sequence.
- **Digital flips, flops, flies, spins, wipes, and zooms** It's eye candy and should usually only be used to inject a little high-tech glitz (e.g., to keep your audience awake). The rule of thumb is: Use them sparingly!

8. The credits, whether a roll, scroll, or on individual pages, can often be made right from within your editing application. Check your manual for how to make text graphics.

There are a great many technical terms used in digital editing—and indeed in all of video production. Many of them aren't covered here, but it might be useful for you to become familiar with them. I suggest you use any popular search engine and type **video glossary** or **video editing glossary**. Several good sites will list and define many of these terms.

The Editor's Mindset

Being a video editor is a demanding job that requires long hours of sitting at the computer, worrying over minor details; correcting errors that may have happened during shooting; solving problems when the edit just won't fit together as planned; searching for footage, graphics, and sounds that seem to elusively disappear when you need them; and generally cursing everything and everyone from the producer to the director and the computer you're using. But the upside is that it's a highly creative job that is immensely rewarding as you see that lump of clay (your raw elements) molded and honed into a beautiful work of art. It's a terrific thrill to finally lean back in your chair and view the finished product from the point of view of the audience.

As I write this I'm looking forward to this evening's television broadcast of a documentary that I edited, and I know I will be just as thrilled to see how all my hard work turned out as I was the last 40 times I saw it (okay, I'm a little narcissistic). To be an editor you have to be prepared to see the same footage and hear the same music tracks over and over and over and over and over, etc., etc., etc., etc., ad infinitum! But it's a blast!

Remember, you can only learn how to edit by doing it!

10

That's a Wrap

Although the title of this chapter is a bit trite, we really are at the end of the journey in learning the basics of video production. However, I would like to cobble together some loose ends for you in the last few pages.

Creative Thinking

This is not a self-help book that will teach you everything you need to know about the creative thought process, but I do have a few suggestions that work for me when my idea well runs dry.

Where Do Good Ideas Come From?

The creative process is often elusive. Just when you need to spawn a winning idea, it can't be easily jump-started. If you sit down with no preconceived ideas as to what you'll create—either as a full project or parts of one you're already working on—and try to come up with a genius concept immediately, you'll likely sit there twiddling your thumbs and staring at the wall for a long time with no results. Instead, try these (almost) guaranteed, drug- and alcohol-free methods to get the artistic juices flowing:

- Take a few deep breaths and go for a long walk or sit quietly and don't think about it too hard. If you just let it simmer in the base of your brain, eventually good ideas will rise to the surface.

- Watch a little TV, thumb through a magazine, or read a book. Try not to become too involved in the stories you see or read, but look away from the TV or printed material before a story point can be fully explored, and create your own take on what might happen next. You might just create a whole new story on the spot.

- Mull your problem over just before going to sleep at night. I sometimes solve problems by dreaming of the solution. It's said that Robert Louis Stevenson plotted the entire story line to *Treasure Island* while sleeping.

- Brainstorm with other people. This is, by far, one of the best methods for churning up and honing ideas. During many of the video production courses I have taught over the years, I will often have my students gather in discussion groups. Everyone throws in ideas until one really clicks with the whole group. Then I encourage them to flesh out the idea, add detail, discuss how and

where shooting will be accomplished, and delegate tasks among themselves. It's good to have a group leader/moderator for this session (perhaps the director, who has the final say).

Tools of the Trade

Besides your editing software, there are many auxiliary programs you should consider having in your arsenal of post-production tools.

Stocking Your Digital Toolkit

Every beginning filmmaker starts out with an idea, a camera, and an editing application for their computer. With these three basic tools you can make a complete program. But if your concept calls for interesting special effects; fancy titling beyond what can be done with your editing program; and maybe some character, object, or text animation, you will likely need some extra software.

There are hundreds of options out there to satisfy any of these needs. The best advice I can give you when shopping for software is to carefully compare features and prices, and vendors that allow you to download a free trial. Often these trials will allow you to use the software with certain restrictions that make it necessary to purchase the program before you can actually use it in your production. Some will allow full use for a limited time.

The first piece of software that I can highly recommend is called Celtx (http://celtx.com/). The reason I am mentioning this one first is that you'll likely use it before any of the other production tools described in this section. Celtx is script writing and production planning software that is *absolutely free* (and worth every penny!). Really, it's fantastic software! Figure 10-1 shows one of its more common formats for dramatic script writing.

Celtx's sophisticated suite of programs allows you to script in formats specific to feature films, audiovisual (AV) projects, audio programs, and even comic books. It will enable you to turn out storyboards, production schedules, character breakdowns, location information, etc. Celtx's online component includes help files and a community of users to interact with.

FIGURE 10-1 One of Celtx's sample screens shows a screenplay format.

A long-time industry standard used to create motion backgrounds and graphics, as well as stunning visual effects, is Adobe After Effects. This is available for both PC and Mac, and would be a valuable addition to your digital tool bag.

Another motion graphics program that isn't used to produce transitions, but specializes in motion backgrounds, effects, and fancy text is Apple's Motion. This program used to come with the Mac-only version of the Final Cut Pro suite of software. It is now available as a stand-alone purchase and has been significantly updated. Motion works on its own to create great effects from both moving and still images as well as text. (see Figure 10-2).

FIGURE 10-2 You can set up and animate hundreds of effects with Motion.

While After Effects is rather expensive at $999 (hey, you get what you pay for) Apple's Motion is currently (as of this writing) $49.

There are also a number of programs I use to help make interesting visuals that are inexpensive and yet fairly sophisticated. Kinemac (www.kinemac.com) is a stand-alone package (Mac only) that allows for easy animation of both 2D and 3D primitives (cubes, spheres, flat planes, cylinders, etc.) and even text. The learning curve is much less than with the more sophisticated programs, but with this program you can

FIGURE 10-3 This is the set-up of my planet fly-through animation with Kinemac.

create some dazzling effects. I recently had occasion to map actual images of planet surfaces to spheres in Kinemac to create planets and moons orbiting and rotating in space (see Figure 10-3). It looked great and didn't take long to set up. At $299.00 at the time of this writing, it's a great tool to have at your disposal.

DV Kitchen (www.dvcreators.net) is a $79.95 (at this writing) solution for those Mac people who have not acquired a suitable, or understandable, compression program to convert videos from format to format (to or from QuickTime, Flash, Windows Media, iPod, iPhone, etc.) and to set video for web streaming, downloading, or e-mailing (see Figure 10-4). DV Kitchen handles videos (of course), stills, and audio and will also publish media to your website. It's easy to create a "recipe" (Get it? Kitchen? Recipe?) to suit your bandwidth, file size, etc. Very handy.

FIGURE 10-4 DV Kitchen main screen: setting up to compress

DVCreators also has many other pieces of interesting software and learning aids for both Mac and PC, including reasonably priced and sophisticated teleprompter software (something that can be hard to find and is usually quite expensive).

By far, my most favorite program just for sheer creative play, as well as its usefulness in illustration and animation, is a free application called Daz 3D (www.daz3d.com). This really cool program, which is available for both Mac and PCs, comes complete with several 3D models for you to begin your journey into the world of 3D design. The models are fully articulated and posable, and you can even light them with several light sources, colors, intensities, and shadows, just like you see in the real world.

Of course, you will want to purchase other 3D objects (animals, monsters, dinosaurs, sets, props, clothing for your human models, textures for several types of models, etc.), as shown in Figures 10-5 and 10-6, and that's how Daz makes its profits. But most models are quite inexpensive, and if you build your content slowly, your credit card won't explode. Figure 10-7 shows the effects in their final form.

FIGURE 10-5 Your imagination is the limit when it comes to working with 3D effects in Daz.

FIGURE 10-6 Models and lighting being set up in the staging area for two different fantasy illustrations

FIGURE 10-7 The final renders of the Daz 3D setups

There's an advanced version of the software (unfortunately, it's not free) that adds numerous upgrades to the rendering and animation process. My professional use of this product includes static illustrations ("The ancient Egyptians were the first to utilize astrology as a science.") or sometimes an animation (showing a devastating accident without hurting a real actor). Several of the illustrations in this book (the female model in the section on lighting, the Western saloon, the cereal killer character, and the "Using Cue Cards" picture, for example) were set up by me and rendered from Daz Studio.

Other Software Suggestions

The programs described in the previous section are some of my favorites. They are usually easy to get some good use from, though some, like Apple's Motion, have a steep learning curve if you want to find out all that they can do.

My other suggestions for software to complement your editing environment include a good graphics manipulation program like Photoshop, a good paint program, and as many fonts as you feel you might need for different titling situations.

It's Trite, But…"That's a Wrap!"

Well, I can't think of anything else to tell ya. I'm sure I could drone on and on, casting pearls of wisdom until your head exploded, but I really think that what I have included in this book is the best all-around basic knowledge that I can give you to help kick off your career in making *fabulous* video productions.

Now, be creative… practice and play… and have fun!

Index